WILD LAND

WILD LAND

Images of Nature from the Cairngorms

Peter Cairns and Mark Hamblin

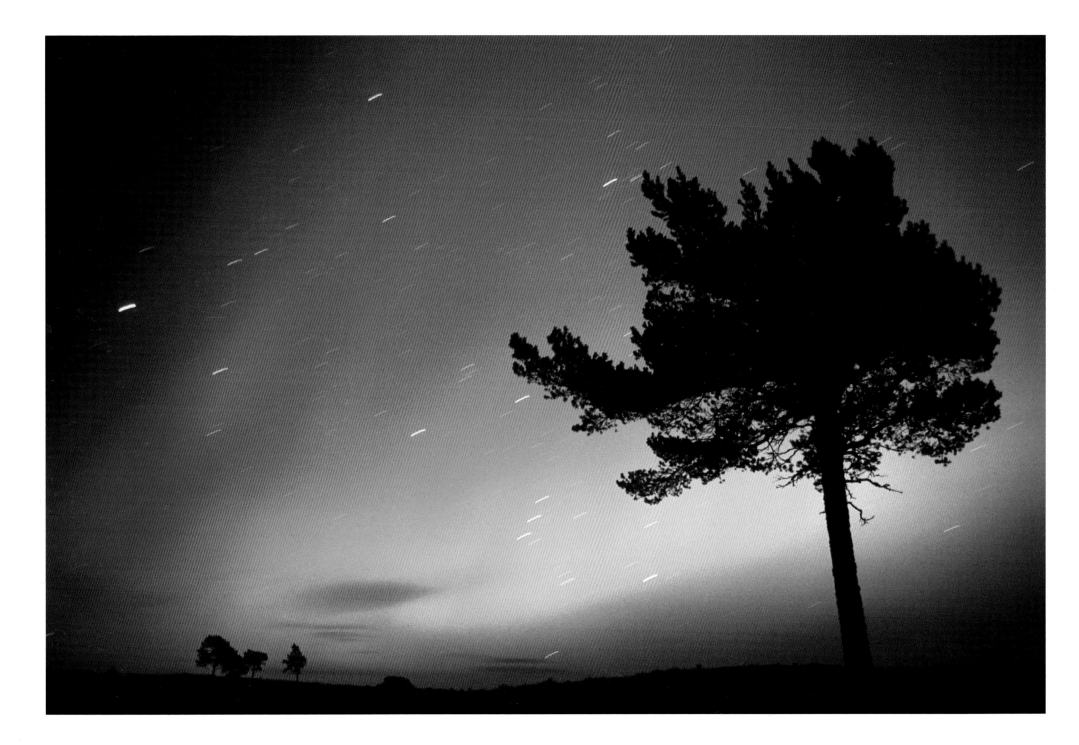

The dawn of a new millennium and the designation of the Cairngorms as Britain's largest National Park are both milestones that called for a visual celebration of the natural wonders found within this special place. *Wild Land* was conceived as exactly that, but developed into something more—something deeper, more fundamental and ultimately more challenging. The Cairngorms National Park remains an evolving environment and is not without its share of contentious issues. As we set about choosing the images for this book, we were both surprised at how readily we avoided the temptation to portray the Cairngorms as a pristine wilderness. Instead, we have tried to convey an essence of wildness that sits alongside man's influence over the forests, mountains, rivers and moors, together with the wildlife that depends on these fragile habitats. We have also tried to give an insight into how we perceive and react to the wildlife that we set out to record on camera. As working nature photographers, we have a passion and an empathy for our subjects which we have attempted to portray through our choice of pictures. The book features many of our favourite images—some hard-won, others more opportunistic, but all of them fleeting moments, special moments. This book is about a place that has been changed by man over millennia, yet remains wild at heart. We hope the images on the following pages will leave you with a sense of that wildness—its beauty and its fragility.

CONTENTS

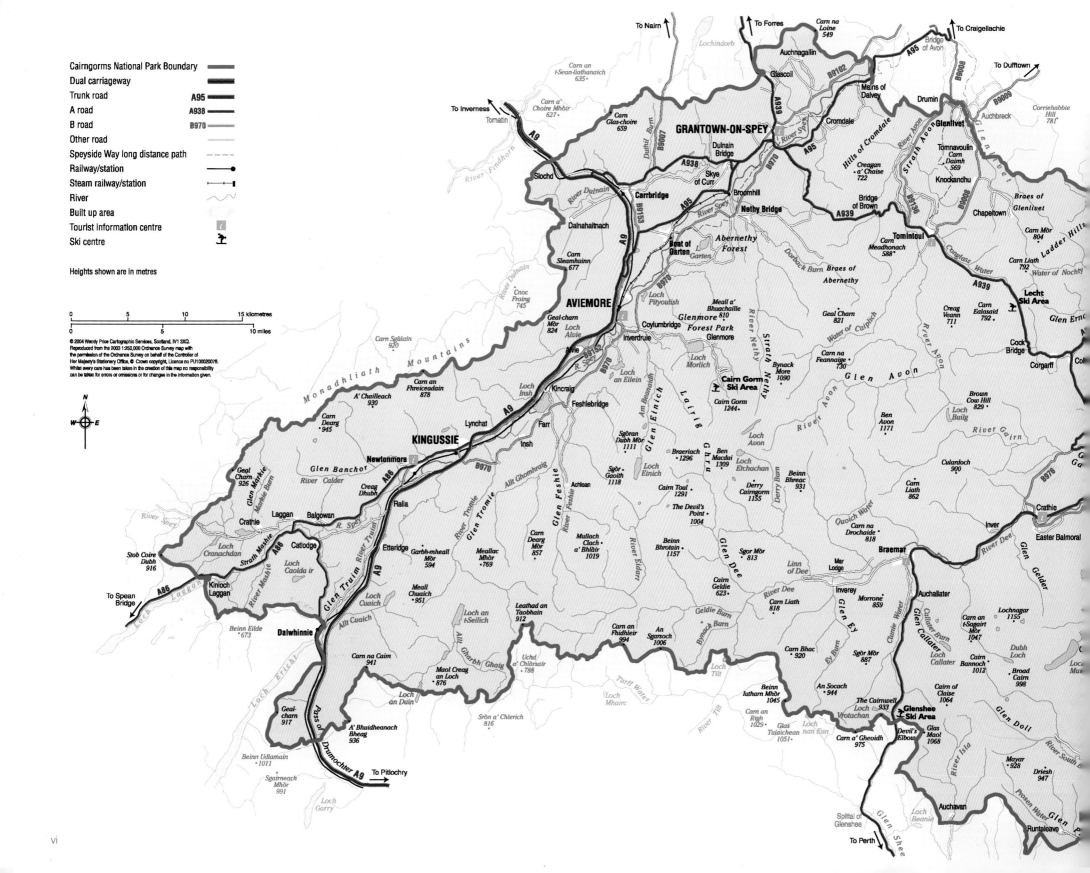

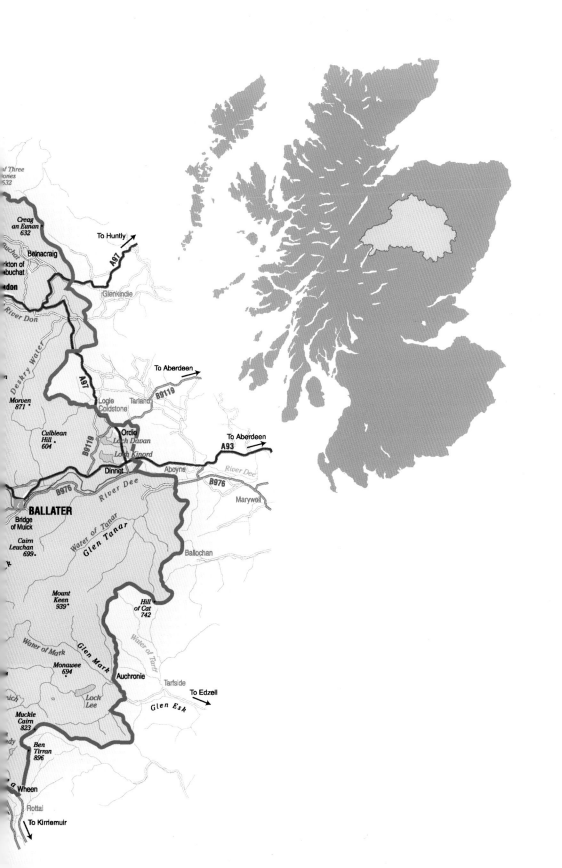

Peter Cairns

Peter Cairns grew up in the Midlands and developed a childhood passion for the natural world from his grandfather. Following a fifteen-year spell running a road transport company, Peter turned his back on business in 1994 and moved to the Scottish Highlands. Originally working as a wildlife guide, he now runs his own photographic library, *northshots*, focusing on Scottish wildlife and accompanying political issues. Peter is also involved in developing wildlife tourism initiatives both in Scotland and in Scandinavia. He lives in Kincraig in the Cairngorms National Park with his wife Amanda and son Sam.

www.northshots.com

Mark Hamblin

Born in Warwickshire in 1966, Mark Hamblin first became interested in wildlife following a gift membership of the Young Ornithologists' Club. After studying microbiology at Sheffield University, Mark decided that it was time to pursue his love of wildlife photography, turning professional in 1995. His photographs are regularly featured in national publications, books, calendars and other media. Mark is also a partner in *wildshots* (www.wildshots. co.uk) leading holidays in the Highlands and overseas. Although widely travelled, he now works principally in Scotland following his move to the Highlands with his partner, Gale, in 2002.

www.markhamblin.com

A BOREAL WILDERNESS

The strength of the wolf is in the pack,

but the strength of the pack is
in the wolf.

[Rudyard Kipling]

A gently swirling mist hangs over a forest mire, reeling in its tendrils to reveal the ghostly silhouette of a foraging bear. In the cool autumnal air, instinct urges the bear to feed before his long winter hibernation. The distant howl of wolves is carried on the breeze. The sound does not go unnoticed by the bear—a good meal can be had from the carcass of a wolf-killed moose.

The warm tones of autumnal birch and rowan gain vibrancy as the morning sun seeks out the forest floor. The yellowing leaves of aspen quiver, dancing in the sunlight against a backdrop of deep green—a sea of pines stretching away into the distance and melting into the mist.

The hoarse bark of a nearby roe buck signals a warning to others of its kind. The stealth of a prowling lynx is consummate yet the buck's finely tuned senses have foiled its morning's work. The bear's presence has alerted a family of wild boar rummaging amongst the leaf litter—they now stand motionless amidst the dense forest understorey.

In an open glade, a peat-stained pool is disturbed by the emergence of a beaver swimming low across the water, resembling the log it now carries to its deftly engineered dam. In the shadow of the snow-dusted mountains, the wolf pack return to their kill deep in the forest. Above them, attendant ravens await their turn; nothing will be wasted.

The bear has been on the move since before dawn. His varied diet is well served in the rich forest and he will enter winter slumber in peak condition. As he squelches through saturated moss, he disturbs a capercaillie feeding on blaeberries, the clatter of wings startling the bear as the grouse retreats deep into the forest. He sniffs the air before continuing on his way, the sun now warm on his back.

Emerging from a blanket of ice a mile deep that had carpeted the land for a hundred centuries, this was the Cairngorms of the distant past. It was a time when this land, like much of northern Europe, had been left scoured, barren and almost devoid of life. It is a scene now barely imaginable on our tiny, orderly island. Yet distant as it may seem, bears, lynx, moose, beaver and boar roamed the forests of the Cairngorms little more than fifty human lifetimes ago. The howls of wolves were silenced barely 250 years ago.

To the barren moonscape of post-glacial Britain, a migration of new life came from the south led by pioneering plant species adapted to the hostile conditions. The first arboreal explorers—birch, rowan and aspen—found a vast rolling tundra of rock, mosses and arctic lichens. Herds of reindeer flourished as they do today across Scandinavia and North America. These early colonisers of the northern uplands formed the embryo of what was to become a more complex ecosystem of inter-dependent flora and fauna. The widespread and adaptable Scots pine, that thrives on shallow, sandy soils, soon found its way north and became the predominant tree species in a wilderness of primeval boreal forest. Willow took hold on the lower, boggy ground, while alders grew in thick stands along the glacial river valleys.

As the climate became wetter, a mosaic of dense forest vegetation, open glades, blanket bogs and crystalline lochs came to support a diverse range of wildlife species that moved north from mainland Europe, all keen to fill their own ecological niche in this new temperate haven. Access was afforded by the land bridge that still connected Britain to mainland Europe—a bridge that would ultimately become submerged some 6000 years ago, under a rising sea.

Large predators such as wolf and bear, which still range across much of eastern and northern Europe, followed their prey into the expansive forests of northern Scotland. The increasingly warmer climate provided ideal conditions for huge numbers of small rodents such as mice, voles and, on the higher ground, lemmings. This plentiful food supply in turn attracted predatory birds such as eagles, falcons, hawks and owls. Arctic swans, geese and wading birds that today only visit these shores in winter, bred here, prospering in the food-rich waters of the post glacial period.

Britain became an island cloaked in rich temperate forest—a boundless synthesis of plants, insects, mammals and birds all nurtured from interdependency. A vibrant yet brutal environment, where natural selection weeded out the weak and the sick in an endless cycle of birth, death, decay and regeneration.

At the top of this intricate web of life was one of the most adaptable and widespread species on the planet—the wolf. Able to carve out a survival niche in almost any habitat across its range, wolves prospered in the prey-rich forests, devoid of any direct competition for food or territory. These are mammals with a complex social structure and an efficient, cooperative hunting strategy. They are intelligent creatures and live in family groups, functioning more effectively as a unit than as individuals. These were, however, traits that had long since evolved in another mammalian species, one that was to change the face of this forest wilderness forever—Homo sapiens.

Wolves were perhaps seen as competition for food following the arrival of New Stone Age man some 5000 years ago, whose survival depended on subsistence hunting. These early human settlers and their successors would ultimately manipulate the destiny of all of the large carnivores which had remained undisturbed in the forest for centuries. Over time, the human population increased, and so did demand for food, shelter and trading materials such as fur. Bears and lynx became regarded not only as competition but as a valuable resource.

By the time the Vikings arrived on these shores, the boreal forest that once covered over 3 million acres of Scotland—almost coast to coast—had started to dwindle, and its predatory inhabitants were being hunted down. The Great Wood of Caledon, as the Romans named these northern forests, was now at the mercy of a predatory mammal large in number, cohesive in strategy and equipped with tools to satisfy a voracious appetite for increased economic wealth. By the 10th century, bears, lynx and reindeer were extinct and unsustainable hunting subsequently saw wild boar and beaver both face the same fate.

The demands of an industrialised Britain, along with two world wars, accelerated the depletion of Scotland's forests and increasing affluence in the south led to the fashion of sport hunting. Huge swathes of land were set aside for deer stalking and grouse shooting—activities which remain the cornerstone of rural life in much of the Cairngorms today.

Many creatures with which we once faced the same challenges of survival are long gone, but some, like the osprey, have returned and prospered in these more enlightened times. Our understanding of ecological processes is now more comprehensive than ever before and the establishment of the Cairngorms National Park is testament to the value we now place on our natural heritage. There are few places left on this island where our footprints have not indelibly scarred the landscape, but whilst human activity has shaped the mosaic of habitats found within the Cairngorms, the tiller has perhaps been held more lightly and the vestiges of a wild land can still be seen. (PC)

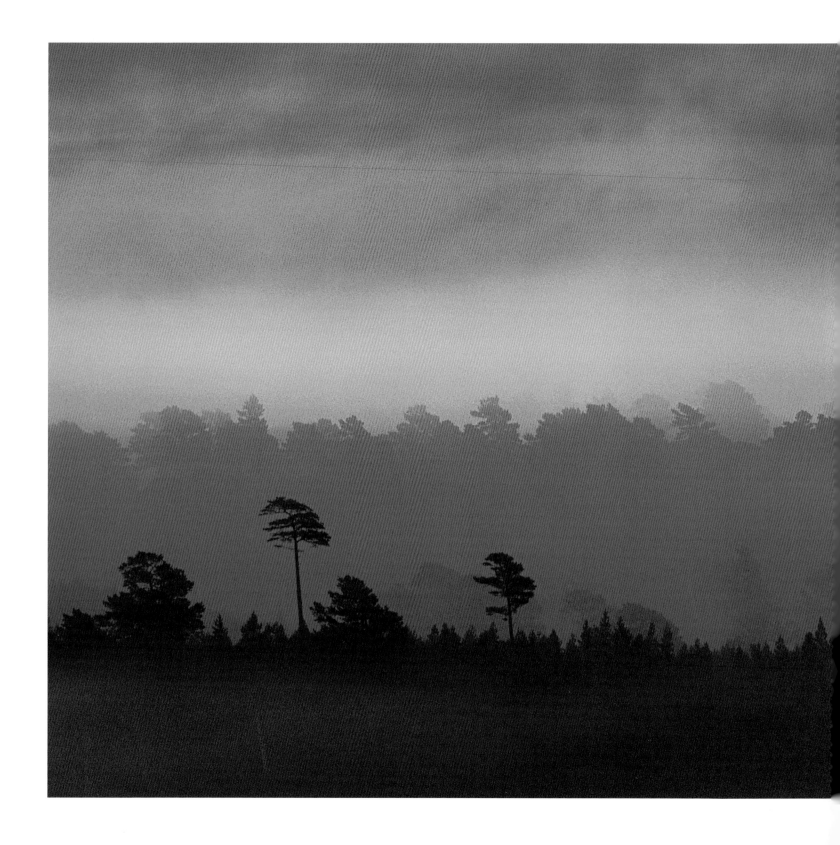

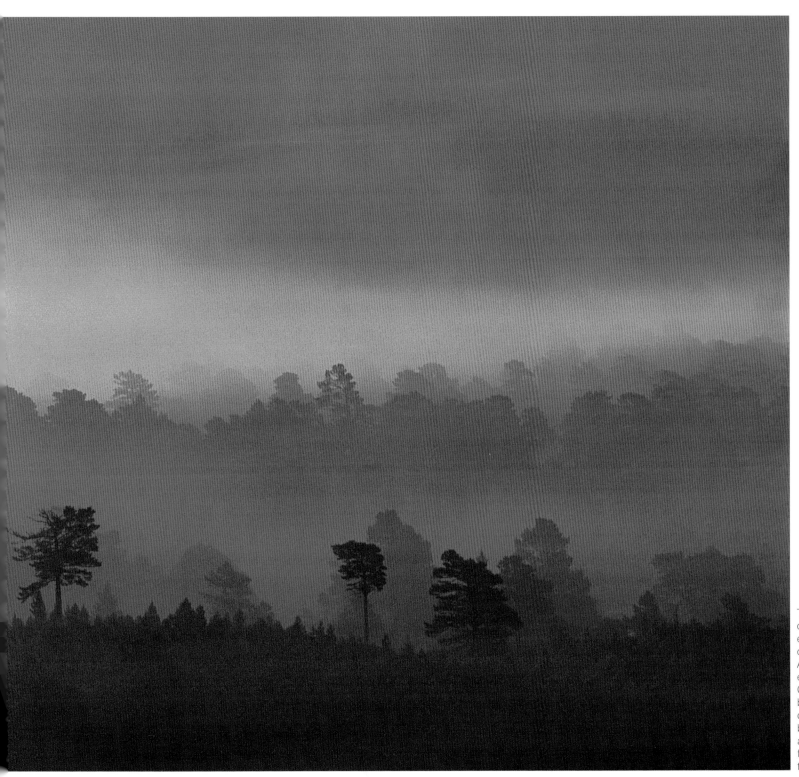

The cool night air had cloaked the forest in an ethereal mist, forming layers of silk among the pines. As the sun rose over the eastern peaks of the Grampians, the forest was bathed in the transient orange light of dawn—backlighting the mist with an intense golden glow. The forest of the past or that of the future? (PC)

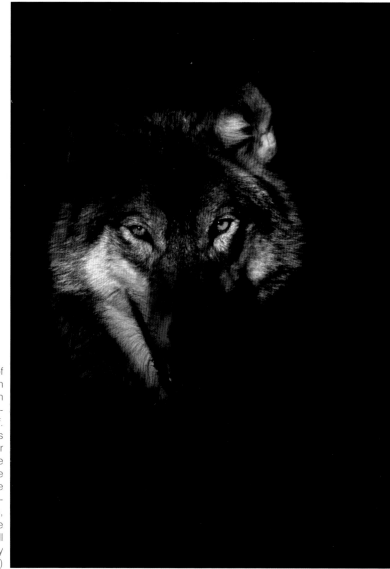

The wolf is the epitome of wilderness. No animal on earth evokes such emotion and none provokes controversy more than the wolf. People's reactions towards wolves are complex. For many it is an animal to be feared, the essence of the devil. For others, it is the ultimate predator, synonymous with wild places, a symbol of hope. It is one of the most studied of all animals, yet remains widely misunderstood.(MH)

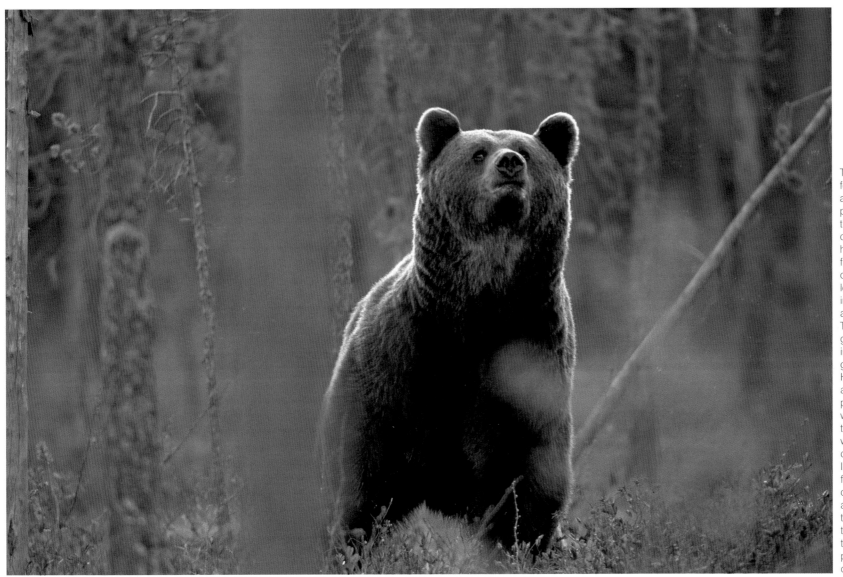

The forest was silent save for the buzzing of insects and the chattering of woodpeckers flitting amongst the dead pines. As the air cooled, a thin veil of mist hung over the boggy mire in front of my hide. Away in the distance I could see the yellow border markers separating Russia from this remote area of eastern Finland. The crack of a dead branch grabbed my attention—an impressive male bear had ghosted into the clearing. He sniffed the air nervously and eyed the hide with suspicion. Satisfied that all was well, he moved purposefully towards the hide. My heart was pounding and although desperate to take a picture, I resisted until he started feeding on the reindeer carcass left out as bait. As a bone snapped between the bear's powerful jaws, the sound echoed through the still night air. I hesitantly pressed the shutter—just once. (PC)

Lynx are one of our two native felids—the other being the Scottish wildcat. They are essentially an ambush hunter, relying on thick cover for most of their kills. Although they have a cosmopolitan diet, roe deer is by far their most important prey item. Recent radiocarbon dating of lynx remains found in Sutherland suggest that they still lived in Scotland in the 3rd century AD. This is significant, as it shows that climate change was not responsible for their extinction, but more likely it was large-scale deforestation and human persecution. For those who dream of native predators being returned to Scotland—as is already happening in other parts of Europe—the lynx is perhaps a more likely candidate than the much-maligned wolf. It is said that there are already free-living lynx (escapees from collections) in parts of the Highlands, with occasional sightings reported. (PC)

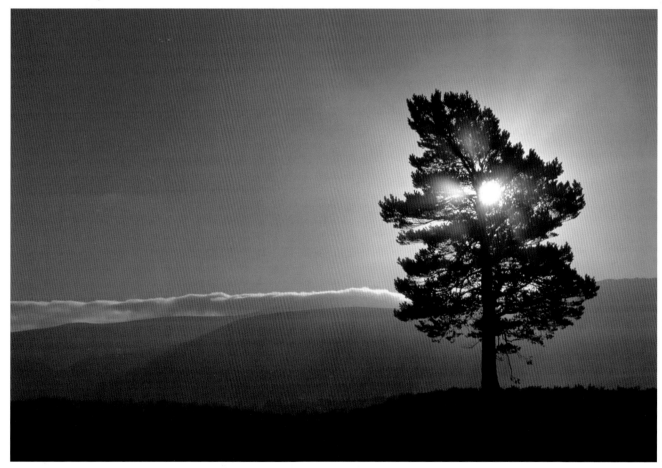

A lonely survivor of the Great Wood or a pioneer to be followed by many thousands of its species as the forest reclaims the open moor? For me, this graphic silhouette, is a simple reminder of a classic September morning, with red deer bellowing in the distance, black grouse lekking and the excited trilling of a crested tit nearby. (MH)

Wild boar were once wide-
spread throughout Britain's
forests and they remain
common across much
of their European range.
They are believed to have
become extinct here around
1300, although reintroduc-
tions for hunting subse-
quently followed. Their habit
of rooting with their powerful
snouts for bulbs, tubers and
invertebrates make them a
valuable forestry tool as they
expose fresh ground for tree
seedlings. (PC)

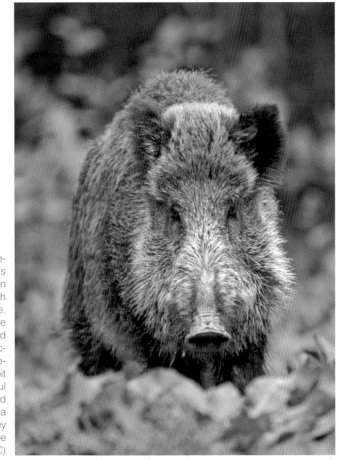

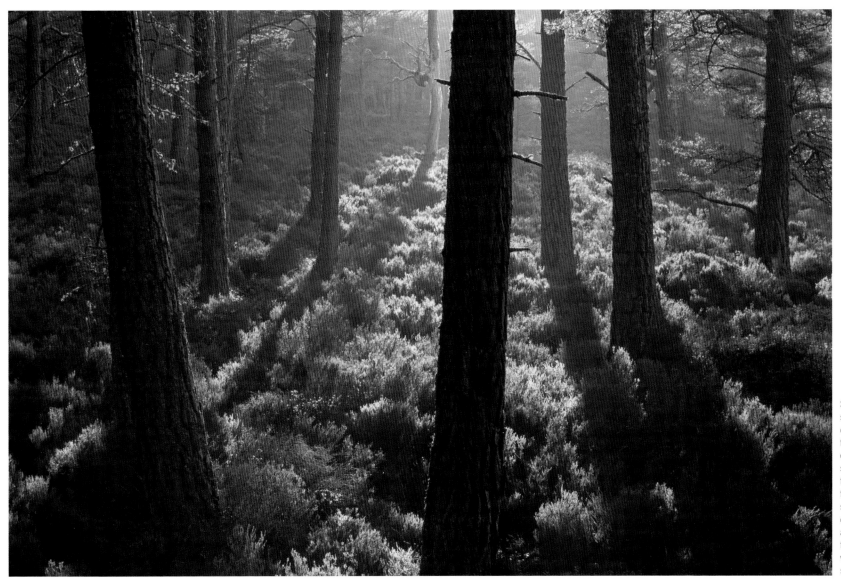

Shortening days and longer shadows signal the onset of harder times for the creatures of the pinewood. The exuberance of spring and summer has passed and the forest is quieter and contemplative. Those that seek solace in milder southern climates have already left and for those that remain, the fruits of the forest are withering and the heartbeat slowing.(PC)

The white-faced darter is a scarce species found in only a few isolated British sites and is a speciality of Strathspey. This individual had recently emerged from its peaty sphagnum pool where, in larval form, it would have been a formidable predator of aquatic invertebrates. In the cool air of early morning, it remained motionless for over an hour until finally, with its wings fully functional, it took its maiden flight over the heather, just as its ancestors would have done throughout much of the boreal forest. (MH)

European bison are thought to have become extinct across most of their range by prehistoric times. The wildwood of the past would have witnessed wolves taking on this most formidable of animals—a challenge not without risk. (PC)

Present in Scotland until the Bronze Age, moose—known as elk in Europe—became extinct at around the same time as the lynx. Their range stretches across the northern forests of America, Europe and Asia, and they are the largest member of the deer family, big males weighing in at 1500kg. The name moose, given by the Algonquin, a native North American tribe, means "eater of twigs," reflecting the animal's primary diet of leaves and scrub. The huge antlers exhibited by the males are grown and shed annually and are used primarily in combat during the rut, which takes place each autumn. (MH)

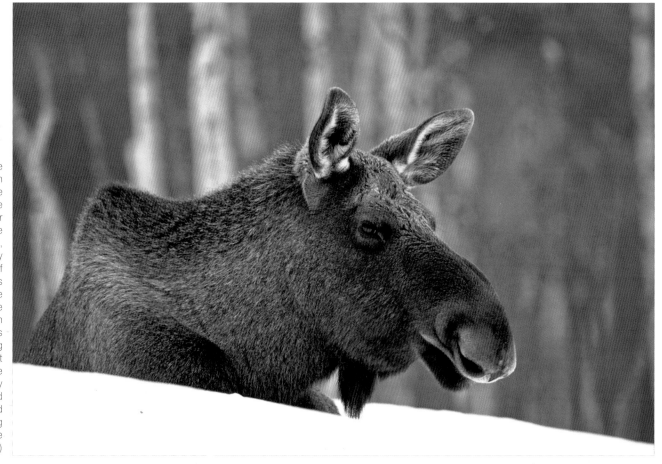

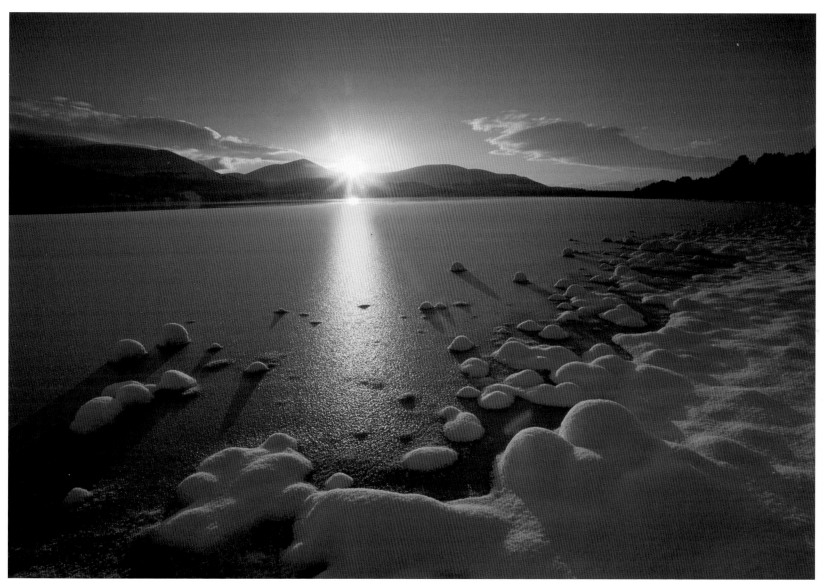

At the height of winter the sun climbs above the horizon only briefly, leaving forest and loch in shadow for much of the day, held in the icy grip of frigid temperatures. Deep snow can cover the ground for weeks on end; the inevitable struggle for life seemingly inappropriate in a landscape of such serene beauty. (MH)

PIONEERS OF THE GREAT WOOD

If a man walks in the woods for love of
them half of each day, he is in danger of
being regarded as a loafer.

But if he spends his days as a speculator, shearing off
those woods and making the earth bald before her
time, he is deemed an industrious and enterprising
citizen.

[Henry David Thoreau]

The rhythmical drumming of a great spotted woodpecker reverberates through the birchwood as he hammers out his territorial claim. His head is a blur of activity as he strikes a favoured resonant branch at up to twenty blows per second. Nearby, a diminutive wren competes, his small frame quivering excitedly as he explodes into song. Pirouetting on his perch, his head moves from side to side, filling the woodland with his dulcet tones. All around, the chorus is heightened with proclamations from redstart, willow warbler, song thrush and robin.

Following the quiet months of winter, the broadleaves come alive in spring as migrants return from their long overseas break. With accelerating day-length and the promise of warmer weather, the pace of life takes on a new dimension. Primroses and violets decorate the woodland floor with a flush of yellow and purple, soon followed by wood anemones, their down-turned white petals streaked with purple veins. Before long, the birches will unfurl their fresh leaves, but by the time the canopy closes over, these early wildflowers have set seed, their job complete for another year.

The Cairngorm foothills and glens support the largest remaining area of semi-natural woodland in Britain. The plight of the ancient pine forest attracts huge public interest, but the pines had their forerunners and the dynamism of a forest ecosystem includes a diverse range of tree species. Birch, rowan and alder are quick to exploit open ground; they are relatively short-lived trees and, in an undisturbed forest, would eventually be replaced by the slower growing pines, forcing the broadleaves to the forest edge. Historically this process has been interrupted by human exploitation.

The birches—silver and downy—are the most common natives. Silver birch prefers well-drained, dry soil, taking a toehold on seemingly impoverished ground, while downy birch gravitates to wetter locations. Both species have an important role in improving soil quality. Equipped with long roots, they draw nutrients from deep within the ground, locking them within their leaves until autumn, when these vital ingredients of life are returned to the top soil. In a highly efficient recycling of nutrients, 3-4 tonnes of leaf litter is generated per hectare of birch woodland.

Ancient birchwoods, such as those found in Craigellachie in Strathspey and the Muir of Dinnet on Deeside, support large communities of insects. Only oak is richer in invertebrates and several priority moth species such as Rannoch sprawler and Kentish glory feed extensively on birch. These in turn form a vital link in the food chain for the many birds that raise their broods in the birchwoods each summer, with the ripening autumnal seeds attracting large flocks of twittering siskins and redpolls.

Like many other pioneer species, aspen has a long history in Scotland and serves as an indicator of ancient woodland. Although now found in mainly smaller stands, due primarily to prolonged grazing pressure, aspen also supports a diverse range of insect life. Some species like the aspen hoverfly being entirely dependent on dead aspen wood. Unusually, individual trees are either male or female, with both sexes producing catkins in early spring. Seed production in Scotland however, is rare, with most reproduction being vegetative, the roots sending out suckers known as ramets. This method of reproduction allows aspen to sustain fire and felling, as the roots can stay alive many years after the death of the parent tree.

Young aspens are particularly favoured by deer and sheep and, in other parts of Europe, aspen are an important food source for beavers. The biological significance and the rarity of aspen in Scotland has implications for the long-awaited re-introduction of this riparian engineer.

Amongst the sea of yellow and gold in late October, the deeper red of fatigued rowan lends further diversity to the forest edge. Growing at higher elevations than many other trees, rowan is a versatile species. In May, its sweet-scented white blossom attracts a host of pollinating insects and by late summer, mistle thrushes and early redwings flock to gorge on its succulent red berries before its leaves turn to the colour of rust.

Equally relished are the dark purple berries of blaeberry, a key component of the forest ground flora and an important source of food for a wide range of wildlife. Although present on the open moor where it is an indicator of former woodland, blaeberry has a preference for acid soil and the shade provided by the forest canopy. Blaeberry is at its best in ancient woodland where it often forms hummocks, drawing up nutrients from rotten stumps on which it grows. Its pinkish, bell-shaped spring flowers are pollinated by bees and wasps. The nutrient rich berries are a favoured food for wood mice and bank voles as well as pine martens, whose purple-coloured scats betray their presence.

All four grouse species found within the Cairngorms feed on the fresh green shoots of blaeberry. For black grouse and capercaillie in particular, it is a vital component of their life cycle, harbouring a host of insects on which the chicks of these vulnerable species depend. Deer have a similar liking for its succulent foliage, and its low-growing nature makes it accessible to mountain hares.

In late autumn, whilst the rich green of the pines holds steady, the celebration of autumn colour provided by the small family of local native broadleaves fades in a blaze of glory. The more robust leaves hang on until early November, then succumb to frost and wind, the trees stripped bare, skeletal, as they await the first snows. (MH)

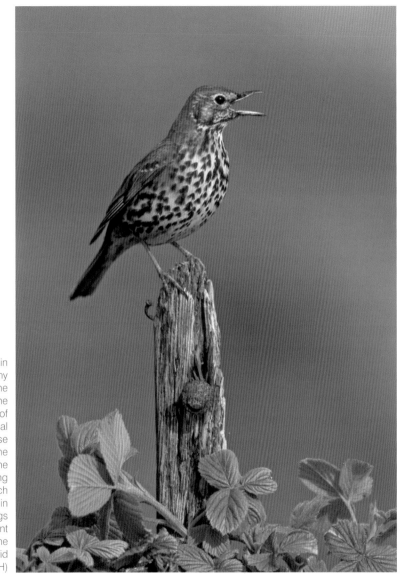

Song thrushes breed in good numbers close to my home in the north of the National Park, choosing the dense cover of a bank of broom in which to conceal their nest. Here they raise two broods during the spring and summer, the parents regularly visiting the garden lawn in search of earthworms. Earlier in spring, the male bird sings from a number of prominent perches from where he delivers his repeated liquid phrases. (MH)

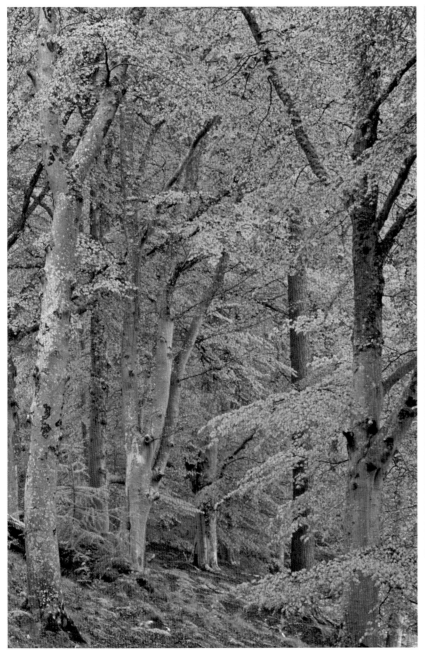
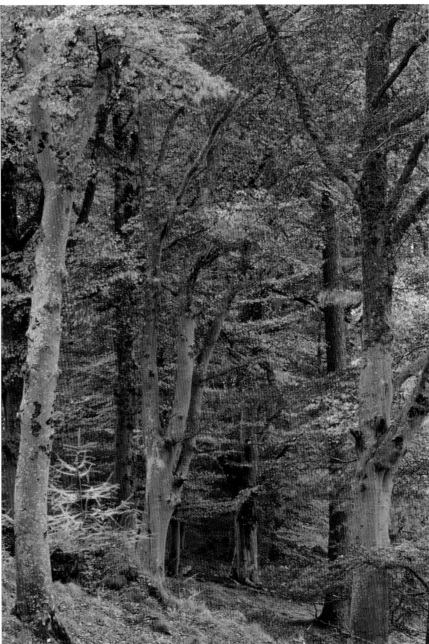

Spring comes late to the Highlands, the vibrant green leaves of beech not appearing from their apparently lifeless branches until early in May. Within days, the unblemished leaves unfurl as the deciduous woodlands flush with life. Within six months, the beech leaves have turned copper-brown, fluttering to earth on the slightest breeze. (MH)

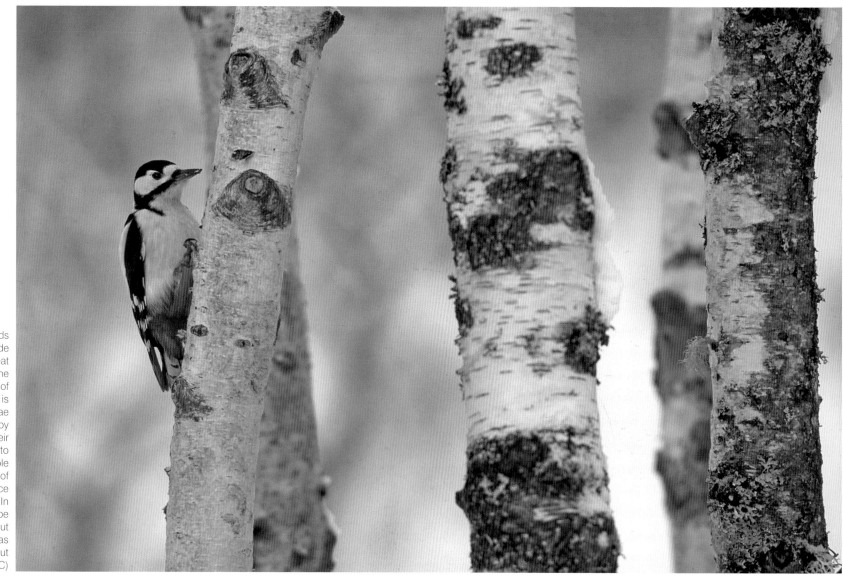

The broad-leaved woodlands of the Cairngorms provide perfect habitat for great spotted woodpeckers. The soft, decaying interior of dead birch and alder is rich in insects and larvae and is easily exploited by these forest engineers. Their powerful bill is also used to excavate a new nest hole each spring, a fresh pile of chippings clear evidence of their industrious work. In winter, they can easily be tempted by nut feeders put out for garden birds—as was the case here, just out of shot. (PC)

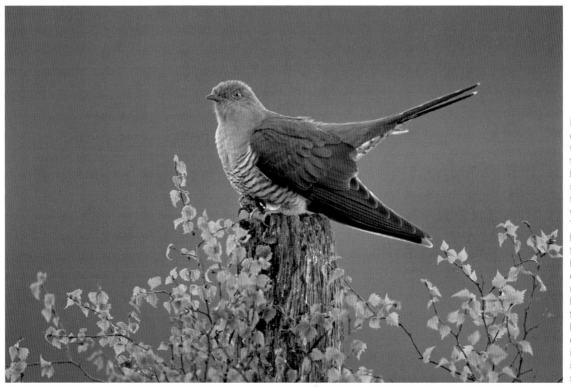

Despite their national decline, cuckoos remain widespread throughout the Cairngorms. Like many birds, they are an edge species, preferring the transitional zone between woodland and moorland. The male bird announces his arrival from Africa with the most recognisable of all bird songs. His monotonous call attracts the female, who responds with an excited babbling. From a high vantage point, the female will bide her time, waiting for an opportunity to slip unnoticed into the nest of another species where she will lay a single egg. (MH)

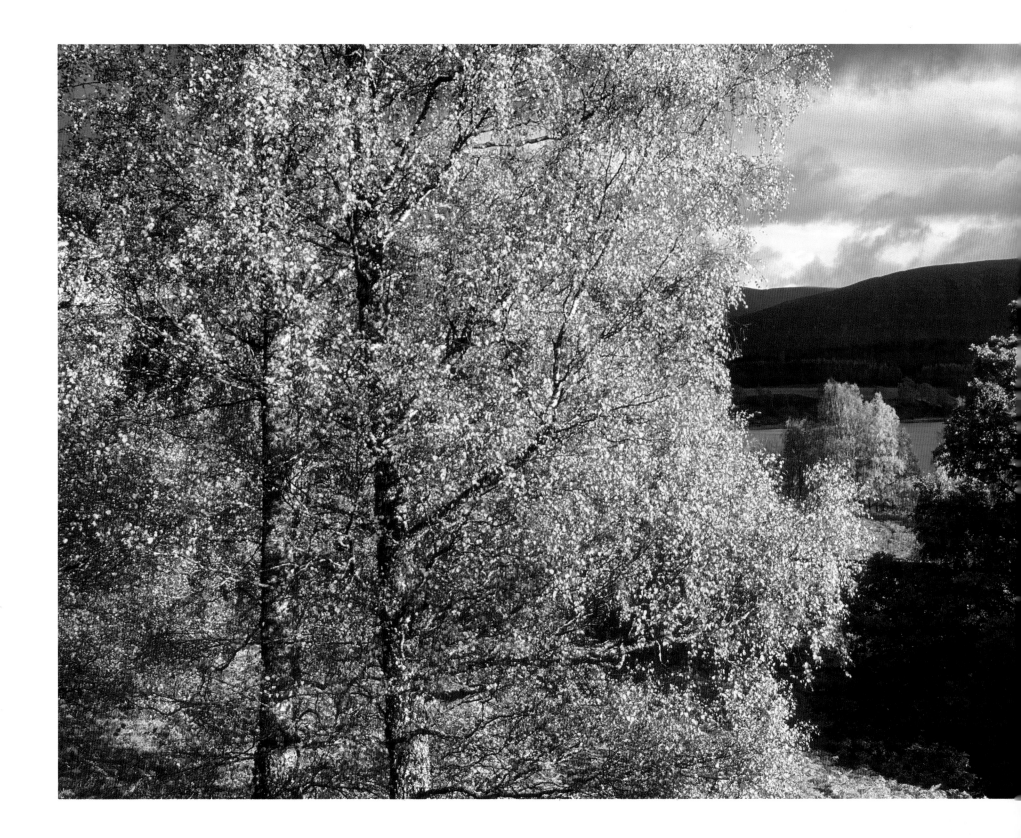

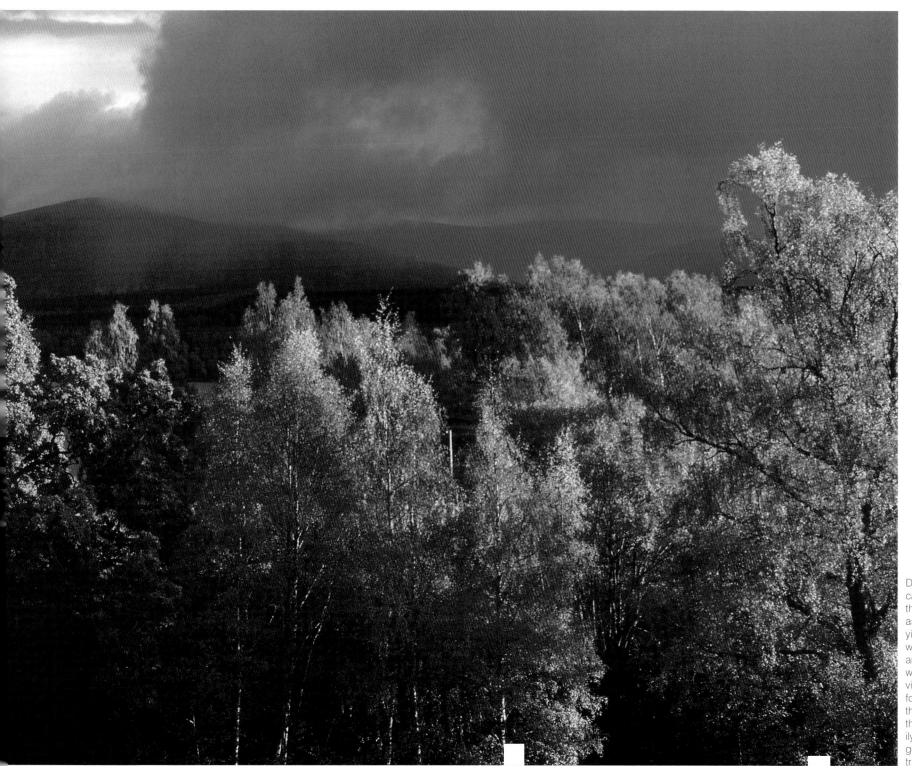

During late October, a carpet of colour unfolds on the lower ground as birch, aspen, rowan and willow yield to the oncoming winter with an offering of yellows and golds. The dynamic weather at this time can provide challenging conditions for the photographer but on this changeable afternoon, the clouds broke momentarily to reveal these saturated golden birches bathed in the transient sunlight. (PC)

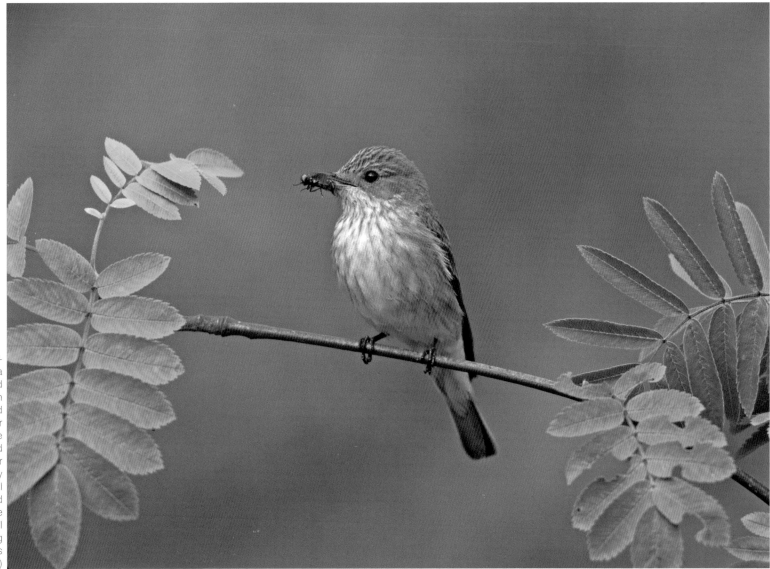

Launching itself spectacularly from a favoured perch, a spotted flycatcher snapped an unsuspecting insect in mid-air. Forever restless and tail flicking, the flycatcher returned to its perch before flying up to its concealed nest in the hollow of an alder where its two chicks eagerly awaited its arrival. My small canvas hide was positioned just a few metres from the flycatchers' nest, where I had been photographing their comings and goings since dawn. (MH)

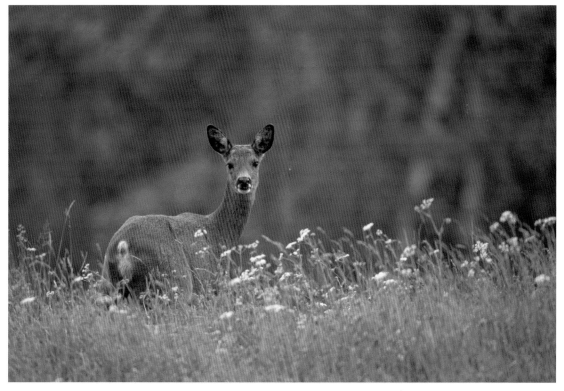

Roe deer are very common throughout the Cairngorms, and can be seen on open moorland as well as their more familiar surroundings of woodland edge. Their annual rut takes place in mid summer, almost immediately after the does have given birth. Roe deer are the only deer species that exhibit delayed implantation of the embryo, which will not start to develop fully until the winter.

This particular doe was very unusual in her confiding nature. She was born close to my home and spent long periods grazing near to the house seemingly oblivious of our activities. She eventually gave birth to her own fawn that subsequently died in its first winter. This doe was shot during a cull in 2001, aged three. (PC)

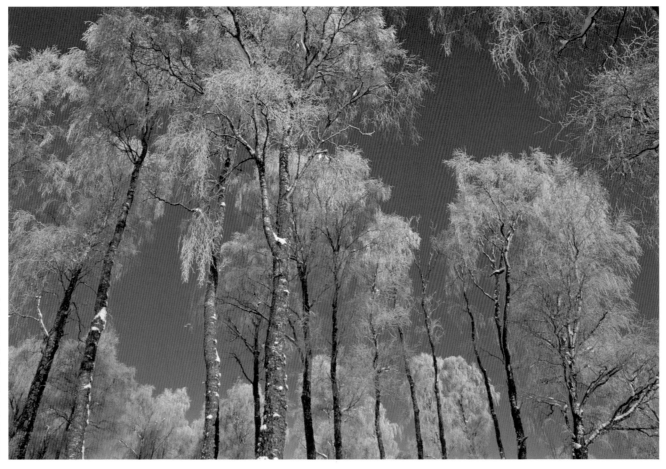

During the night the temperature had dropped to minus 18ºC and a thick mist had carpeted the lower glen. The delicate branches of these winter birches were coated in millions of ice crystals reminiscent of icing sugar. As the dawn mist lifted with the warming sun, an intense blue sky was revealed, providing a perfect contrast to the ice-dusted trees. (PC)

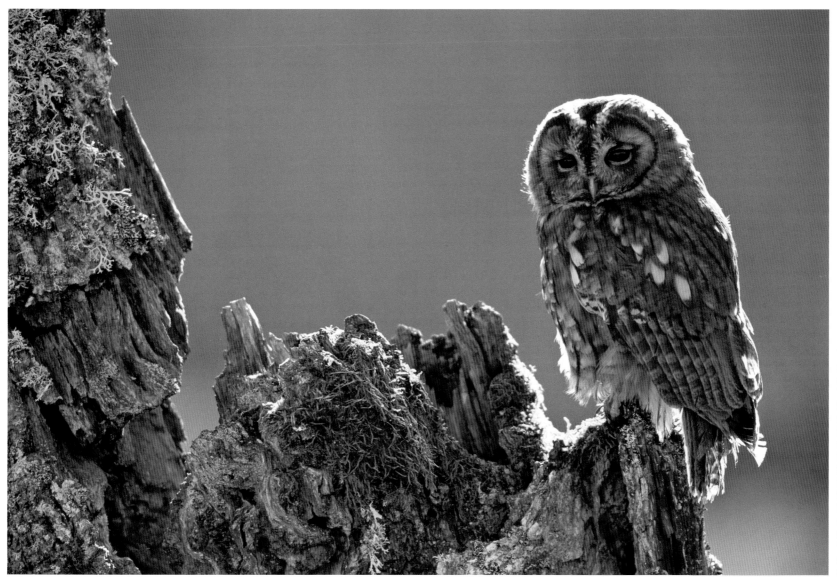

Tawny owls are by far the most common owl species around the Cairngorms. They are early nesters and their haunting duet—the classic "tewit-tewoo" so beloved by TV sound men—is heard most often in late winter as males vie for territory. They nest mainly in hollow trees, but will frequently adopt nesting boxes erected for goldeneye ducks. The incessant hunger of growing chicks means that "tawnies" are regularly seen out in daylight during late spring. (PC)

In many areas of the National Park, self-regenerating birch is becoming more common as grazing pressure is controlled. This sapling, soaking up the evening sun, still has some way to go before it is beyond the reach of hungry deer. (PC)

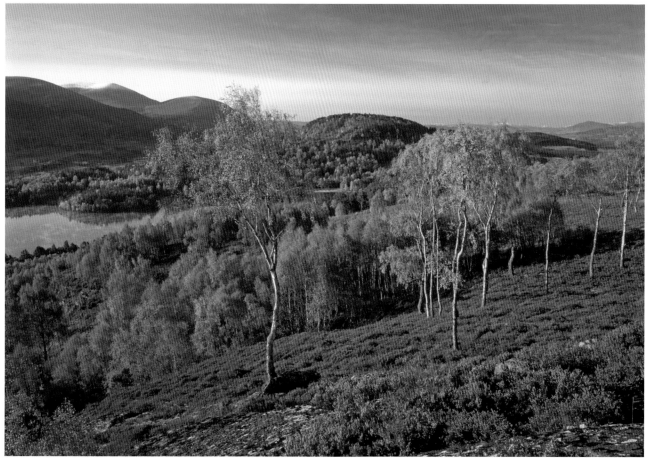

On a perfect October morning, the cold dawn air numbs my fingers as I wait for the sun to cast its golden light across this autumnal scene. A swirling mist partially conceals the blue waters of the loch below, while beyond, the first snows of autumn dust the Cairngorms. As the sun strikes the birches, their yellow leaves intensify in colour. This is peak time for autumn colour, a brief period of two or three weeks in October when the birchwoods are transformed into brilliant hues as the process of chemical reshuffling takes place within their leaves. (MH)

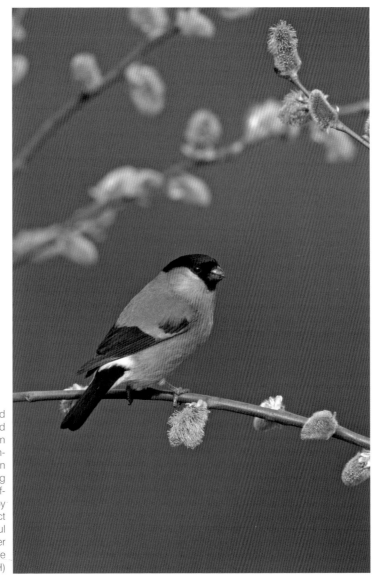

Although widespread
throughout woodlands and
gardens, the bullfinch can
never be considered abun-
dant. They are secretive in
nature, particularly during
the breeding season, but of-
ten give themselves away by
their soft melancholy contact
calls. Bullfinches are faithful
birds, remaining together
throughout the year and are
seldom seen apart. (MH)

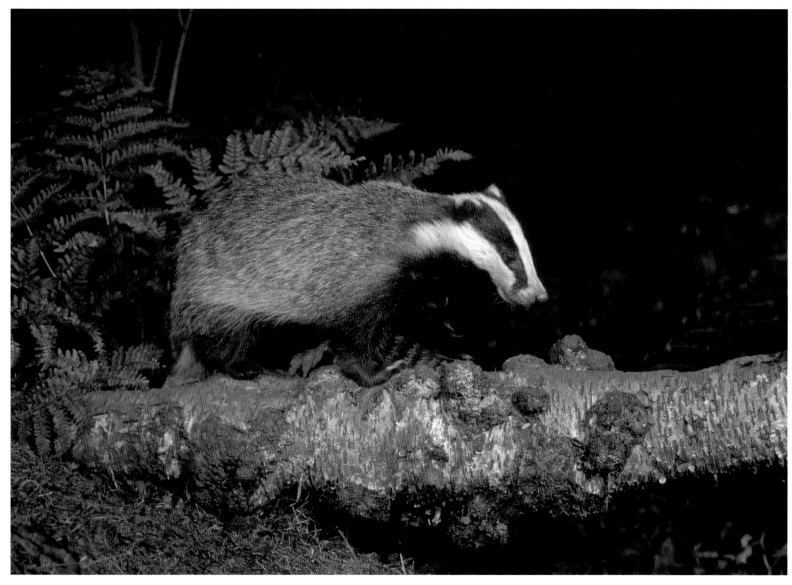

Waiting quietly just a few metres from the entrance to a well-used badger sett, my eyes began to play tricks as the woodland theatre was engulfed in darkness. The silence was deafening as I strained my ears and eyes for any sign of activity. Finally, I detected movement, the merest glimpse of the distinctive black and white face of a badger. Nervous at first, the badger edged its way from its underground sanctuary, nose in the air, its acute sense sniffing for potential danger. Reassured, it revealed itself fully, and after a brief spell of scratching, trundled off across a fallen birch log into the dark woodland interior. (MH)

FOREST OUT OF TIME

We abuse the land because we regard it as a
commodity belonging to us.

When we see the land as a community to
which we belong, we may begin to use it with
love and respect.

[Aldo Leopold]

The Great Wood of Caledon. Five words, but words with resonance; words that you can feel, breathe in and taste. Once the western outpost of a boreal forest, which stretched across northern Europe from the sub-arctic land masses of the east, Caledonian woodland is a tapestry of pine, interspersed with birch, alder, rowan and juniper. It is distinctive, characteristic of the western seaboard and found only in Scotland and parts of Norway. The pinewoods of the Cairngorms—Abernethy, Rothiemurchus, Glenmore, Glenfeshie and Glen Tanar—are rightly celebrated as vestiges of the Great Wood. Some of the contorted 'granny' pines that are still found in these forests stood sentinel as wild wolves passed beneath them 300 years ago.

Since Neolithic times, Scotland's native pinewoods have seen little other than misfortune—events well documented and widely lamented. An incessant onslaught of burning, felling and over- grazing has spared just 1% of the original forest—fragments which themselves are isolated and biologically impoverished. Many of these remnant tracts of natural pines consist of aged trees with few signs of regeneration, a consequence of an imbalance in grazing pressure over the last two centuries. In many areas, deer and sheep numbers remain too high to allow the forest to recover, but this is a complex problem; created by humans and rooted in culture and economics rather than ecology.

Extensive sub-boreal forests similar to the Great Wood still function as intact ecosystems in some parts of northern and eastern Europe. Here they are a mosaic of different tree species of varying age and structure, with indistinct margins. There are no fences. In places, carpets of self-sown young trees flourish amidst an abundance of standing dead and fallen trees. There are areas of dense understorey scrub, open glades and boggy mires.

In mountainous areas similar to the Cairngorms, there is a natural progression of dense forest giving way to sub-alpine scrub and then, as altitude prevents further tree growth, the tundra-like vegetation of the montane zone. This natural diversity is shaped by fire and storm, creating extensive areas of damaged trees amongst which a new generation establishes itself. Foraging wild boar expose the ground to fresh seed and whilst grazing animals browse the young trees, many will grow beyond their reach. Such forests rely on interdependency between all species, including that of predator and prey, but in the absence of key species in our own forests and our intolerance to natural forces, biodiversity is inevitably diminished and the chain of life is broken.

Yet still, the Caledonian pine forest holds its secrets. Exciting and elusive species make their home amongst the trees, some symbolic of an increasing empathy with a re-wilding of the forest.

The pine marten is one such animal. Following centuries of persecution and loss of habitat, they are now expanding their range across the forests of the north. Pine martens are members of the mustelid family, which includes stoats, otters and badgers. They are adept tree climbers and feed on a varied diet of birds, rodents, eggs, berries and fungi. Their speed and agility makes them a threat to a range of tree nesting birds, as well as to red squirrels which have retained a stronghold within the Cairngorms, despite a huge decline elsewhere in Britain. In the absence of larger predators, pine martens have few natural enemies, although they remain wary of hunting golden eagles, foxes and another opportunistic hunter, the Scottish wildcat.

Although visually very similar to the domestic tabby cat, true Scottish wildcats are stocky, muscular animals with a square jaw, a broad forehead and the subtle markings of black, grey and shades of brown, which blend together to afford superb camouflage. Wildcats are most active at dawn and dusk. They are equipped to stalk their prey silently and effortlessly through forest, moorland and farmland margins, striking with breathtaking speed and accuracy.

Similar hunting prowess is employed by the avian predators of the pine forest. Here in the Cairngorms, golden eagles regularly nest in ancient pines and patrol the woodland margins for prey. Deeper in the forest, the dashing goshawk is a powerful raptor capable of taking crows, pigeons and red squirrels. Woodland grouse also provide a welcome meal for a goshawk with young to feed.

Capercaillie are the world's largest grouse species and are entirely dependent on pine forests. As the first light of a spring day splinters through the trees, the 'horse of the woods' performs his ritualistic courtship display to gain favour with onlooking females. The accompanying soundtrack is an other-worldly series of stutters and rasping calls culminating in a popping sound, not unlike the uncorking of a champagne bottle.

Currently, these enigmatic birds have the dubious accolade of being the fastest declining species in Britain and are thought to number less than 1000 in the whole of Scotland. Hunted to extinction in 1785, the present population descends from Scandinavian stock re-introduced in 1837 for sport. They retain small strongholds in forests such as Abernethy.

Their closely related cousin, the black grouse, has also suffered serious decline over recent years and although there are factors that appear to have contributed to the demise of both species, there seems to be no definitive single cause and their status remains perilous.

High in the forest canopy, an agitated, rhythmic trill may reveal the characteristic profile of a crested tit, another pine forest specialist. Within the UK, crested tits are found exclusively in the forests of the eastern and central highlands and are dependent on rotten tree stumps in which they excavate their nest chambers. Although mature plantation forest may provide an increasingly suitable habitat for 'cresties', the skeletal pines of native woodland, with their decaying interiors, support nesting pairs at ten times the density and remain the most likely place in which to see them. Standing dead wood, rich in invertebrates, is a valuable feeding and nesting habitat for other forest birds such as tree pipit, redstart and great spotted woodpecker.

The ancient forest is also the natural home of one of its most important yet controversial architects—the red deer. Where deer numbers are high, they are much maligned for their detrimental effect on young trees and ground vegetation. Their large size and herding instinct inevitably leads to a profound effect on the habitat in which they live. Nevertheless, red deer, together with our other native deer, the roe, are an integral part of the forest and essential to its well being.

In some parts of Scotland, there is a vision for the return of a fully functioning forest ecosystem, complete with extirpated species, thereby allowing nature to manage itself. Some would argue that this is unrealistic and politically undesirable, especially in an area like the Cairngorms which has become highly dependent on tourism. Conversely, the prospect of being able to view some of our 'lost' species in the wild, would undoubtedly boost visitor numbers. Realistic or not, few now contest the value of protecting our remaining native pinewoods, expanding their range and restructuring the way our forests, natural or otherwise, are managed.

Forest conservation presently has more momentum than at any time in the last 150 years, but an expansion of native or semi-natural woodland needs not only to take account of biodiversity but a whole range of human interests, from shooting and farming to recreation and timber. Traditionally, there has been a perceived choice between a wild forest and people. Surely both can be accommodated, leaving only a choice between spiritual well-being or an impoverished future. (PC)

Pine martens give birth to their young in spring, but it is often well into June before they begin to venture away from the den with their mother. The youngster pictured here was one of three siblings, which were visiting a woodland feeding station each evening. The martens usually arrived between 8.30pm and 10.00pm, which even in midsummer allowed very little opportunity for photography in natural light. Over a six-week period, I made repeated visits to the hide, but only managed to obtain pictures on two occasions. The mental images however, will remain forever. (MH)

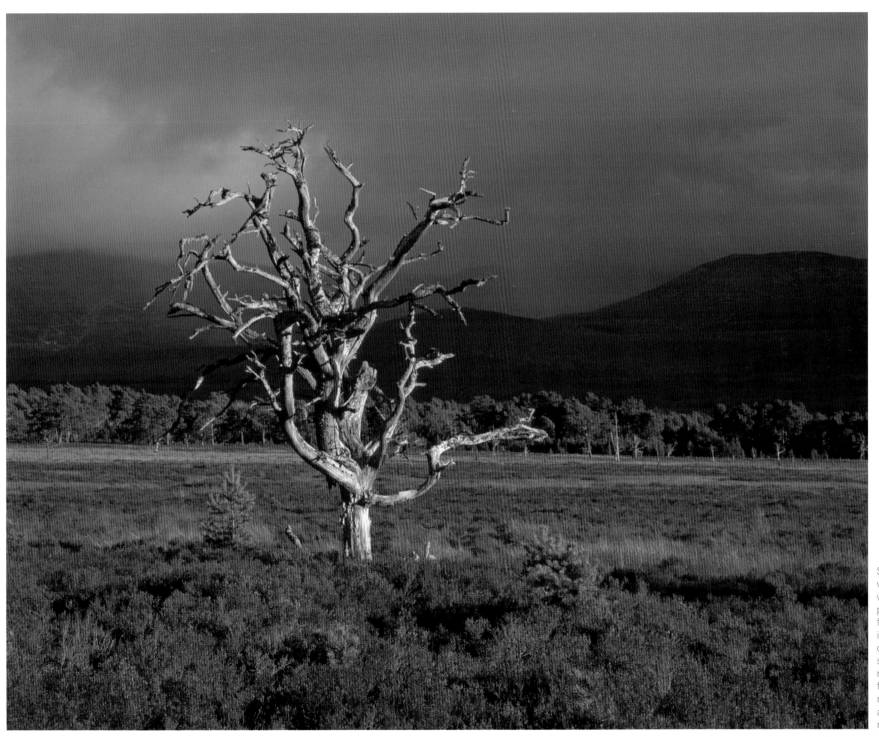

Standing dead wood is a vitally important element within the forest ecosystem, providing the ideal habitat for a range of fungi and insects, as well as a source of food for several bird species. The lack of this resource in many planted forests may be one of the reasons that crested tits are failing to expand their range. (MH)

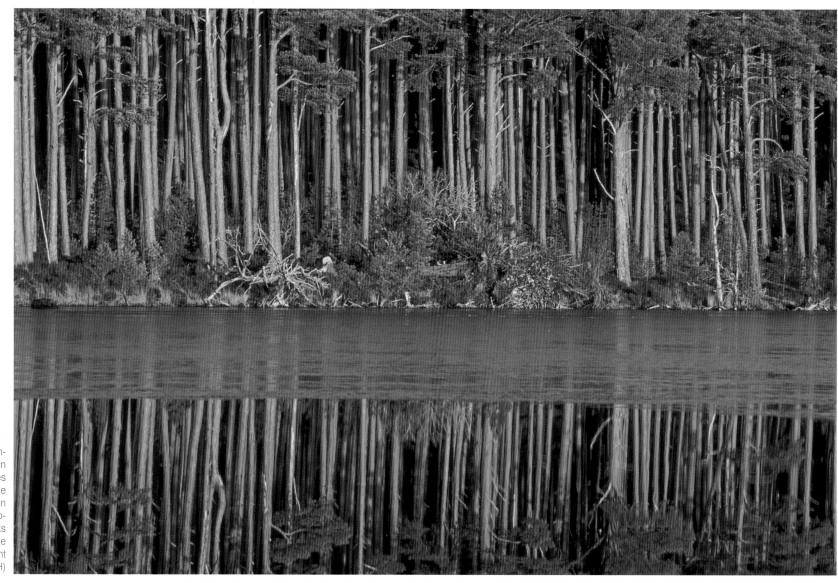

Standing like huge match-sticks topped with dark green foliage, these ancient pines are reflected perfectly in the still waters of the peat-laden loch. As the sun sinks towards the horizon, the trunks turn first yellow, then orange and finally red before the light is extinguished. (MH)

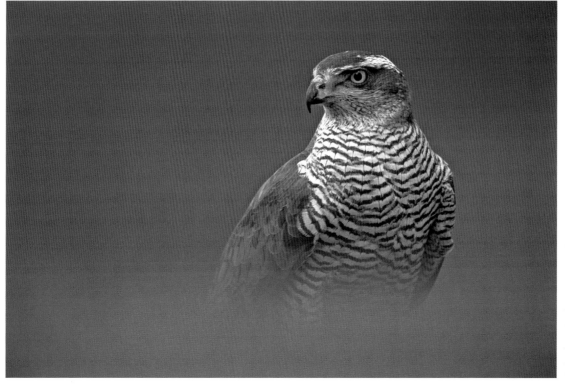

Deforestation and persecution led to the extinction of goshawks in Britain by the late 19th century. An increase in their population over recent decades is believed to be partly attributable to falconer's birds that have either escaped or have been deliberately released. Goshawks are powerful raptors, with the larger females approaching the size of a buzzard. Their agility on the wing through dense forest allows them to ambush prey such as crows, pigeons and red squirrels. (PC)

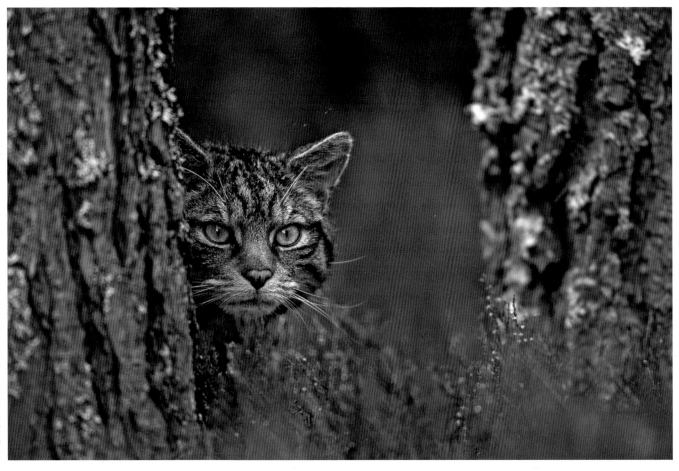

Superbly camouflaged and secretive in nature, wildcats are rarely seen, their footprints or scats the only indication of their presence. They hunt a variety of prey, from small rodents to fully grown rabbits or hares. Their ability to interbreed with domestic cats and produce fertile offspring has brought the genetic purity of true Scottish wildcats into question. (PC)

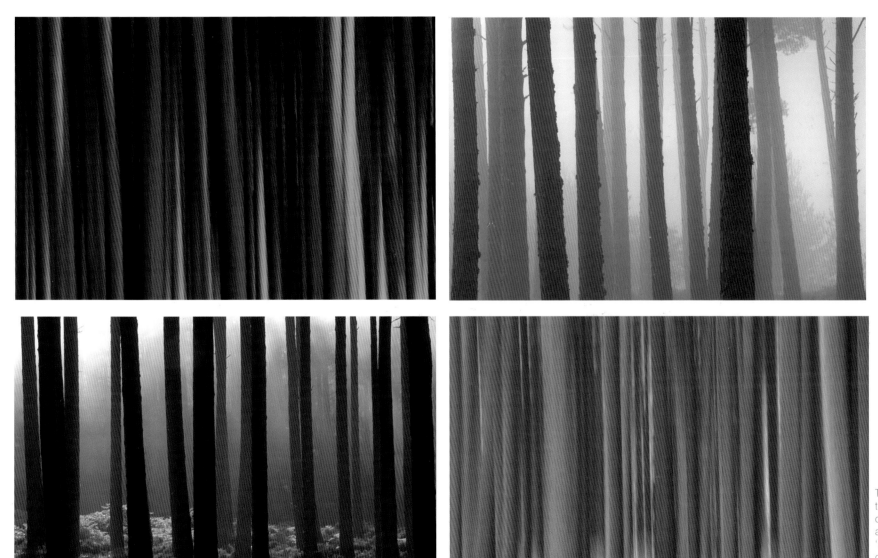

The light that caresses the forest is ephemeral, changing with time, season and weather. Often, the 'busyness' of a forest scene challenges our limited vision, but here, ecological complexity is reduced to visual simplicity. (PC & MH)

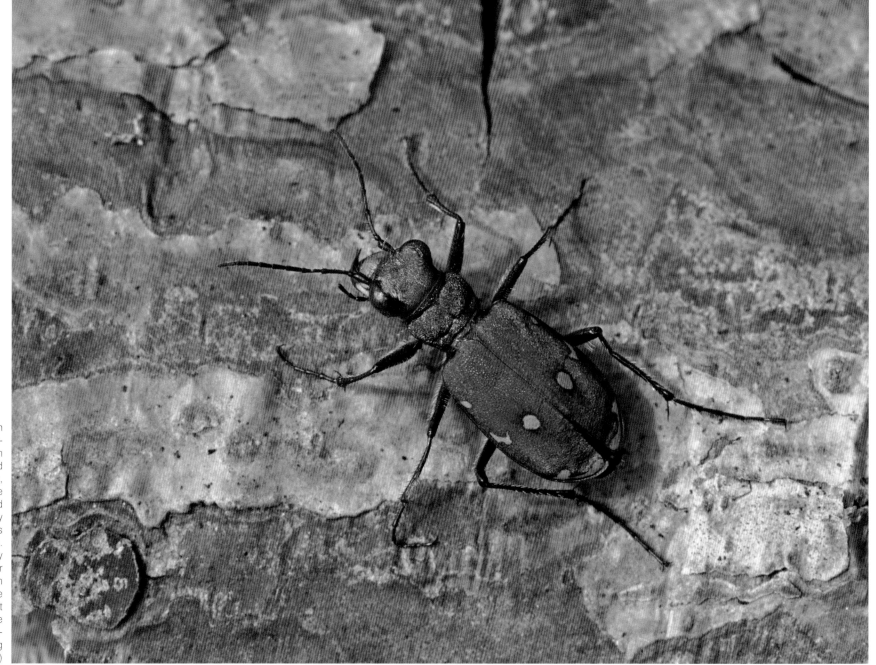

The brightly-coloured green tiger beetle is found throughout the country, occurring on sandy habitats in woods and heaths. Diurnal in nature, they can be seen during the day both on the ground and in flight, a mechanism they use to search for food as well as to escape predators. Like all ground beetles they are carnivorous and use their powerful jaws to feed upon smaller invertebrates. The female lays her eggs just beneath the soil where the developing larvae remain before pupating and emerging as iridescent adults. (MH)

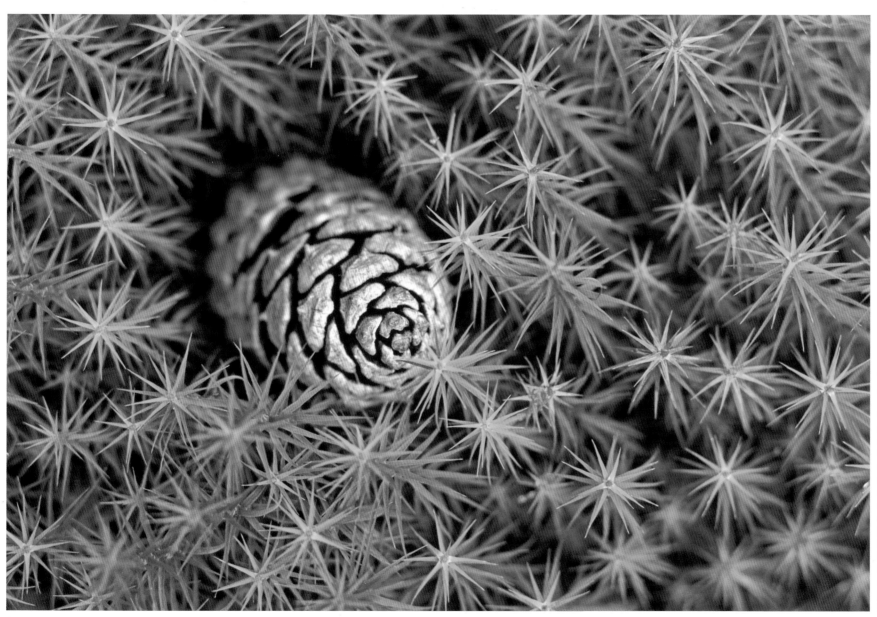

The ancient pine forest is a never-ending source of interest and inspiration as the tapestry changes from season to season. In spring there is emerging life and the forest is vibrant with activity. Conversely, on a still winter's day, the silence can be intense. Despite appearances, the ecological engine that drives the forest is never still. On the forest floor, shapes, patterns, textures and colours form worlds within worlds. The seed contained within this pine cone is the lifeblood of the future. (PC)

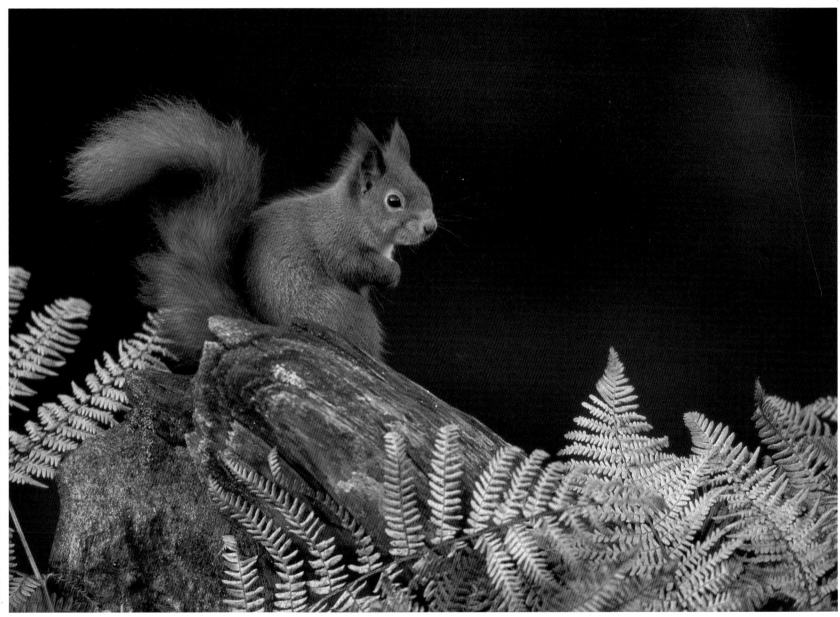

Red squirrels retain their British stronghold in the Cairngorms. To entice these charismatic creatures to within photographic range, I have been putting out hazelnuts on the forest edge almost every day for six years. The animals have become accustomed to this routine and now readily accept my presence. By keeping still and allowing the squirrels to go about their business, they seem to forget I'm there and I have even had one using my head as a lookout post. (PC)

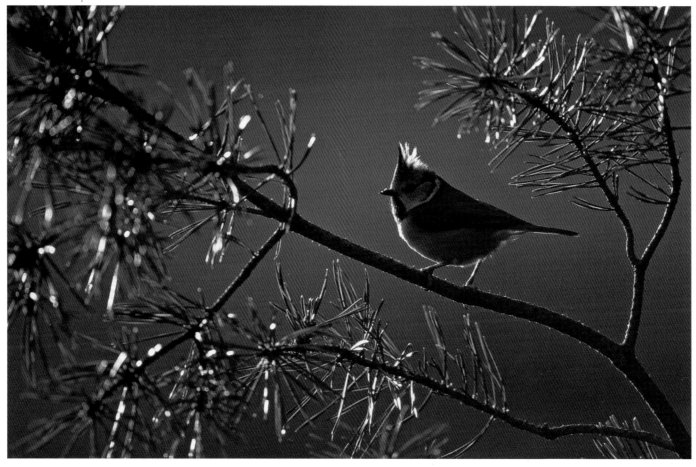

Crested tits serve as an important indicator species, their presence a reassuring sign of a well-balanced habitat. They are present in many of the pinewoods within the Cairngorms, with the highest populations in Strathspey. The distinctive crest is their most characteristic feature, which becomes even more prominent when seen backlit. Following three days of photography, I finally captured a picture that came close to encapsulating all that is special about these enchanting birds. (MH)

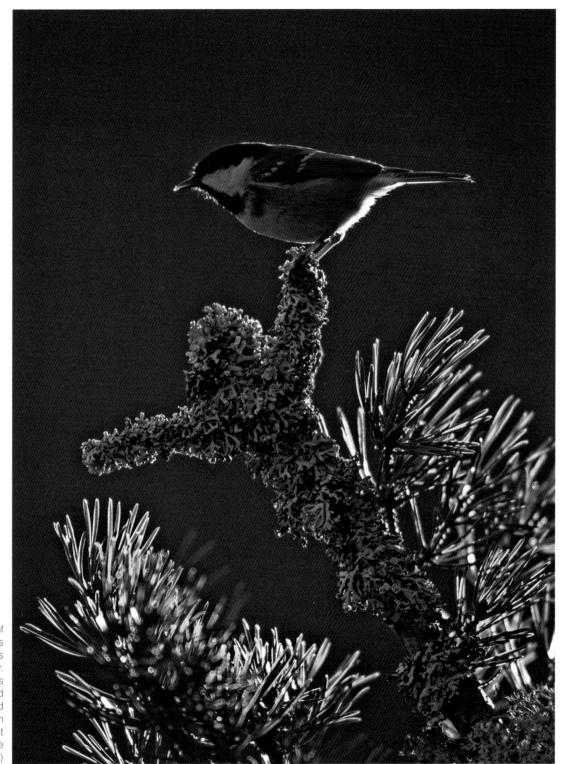

The coal tit is the smallest of the tit family in Britain and is very common in coniferous woodland, especially in winter. Over a period of five days photographing woodland birds one winter, I witnessed three coal tits falling victim to sparrowhawk ambush at almost exactly the same time each day. (PC)

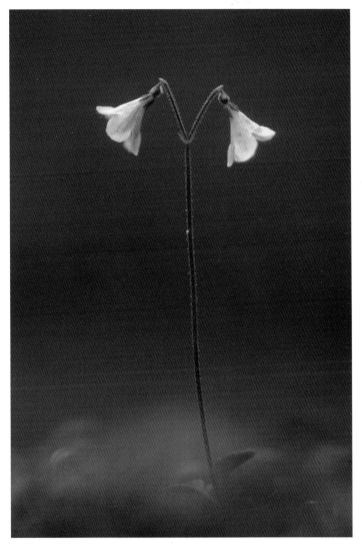

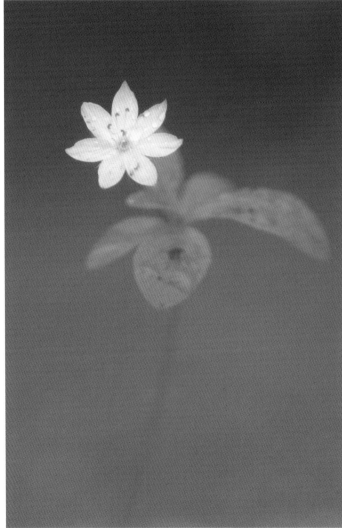

Twinflower (far left) is an arctic-alpine plant that is a relic of the Ice Age and is currently only found at around fifty sites—many within the ancient pine forests of the Cairngorms National Park. Its future status is under threat from several factors, including population fragmentation, overgrazing and felling. Chickweed wintergreen is a member of the primrose family and bears a single flower (occasionally two) in June and July. It grows on acidic soils over much of northern Europe but in Britain it is restricted chiefly to Scotland where it is a locally common inhabitant of the pinewoods. (PC & MH)

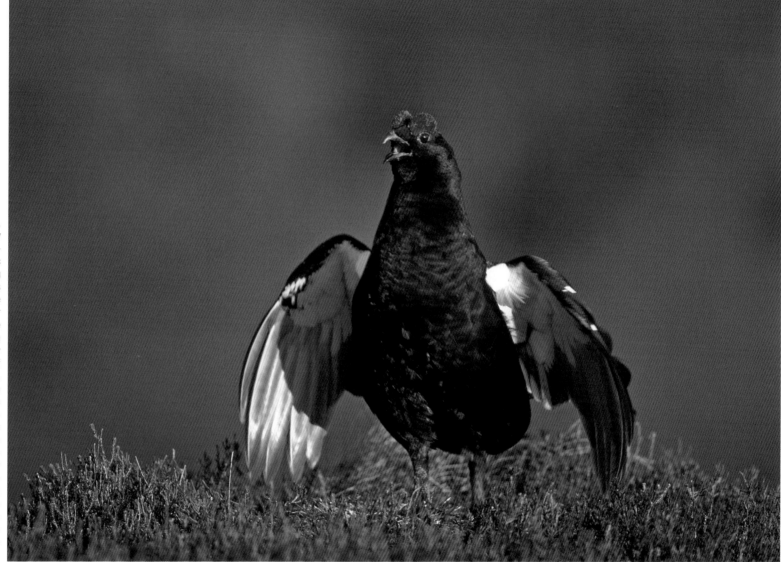

For several weeks in April, Peter and I made our way under the cover of darkness into our photographic hide overlooking the lekking arena of one of the region's most spectacular birds: the black grouse. Soon after our arrival, the first of the "blackcock" fluttered down in front of the hide, quickly followed by the whirring of wings as more birds arrived. Still barely visible in the gloom of dawn, the grouse took up their traditional positions and began their bizarre display of flutter jumps to the accompaniment of cooing and bubbling calls. For well over two hours the birds continued this extravagant display, by which time the long awaited sunlight necessary to capture this action shot was spilling across the lek. (MH)

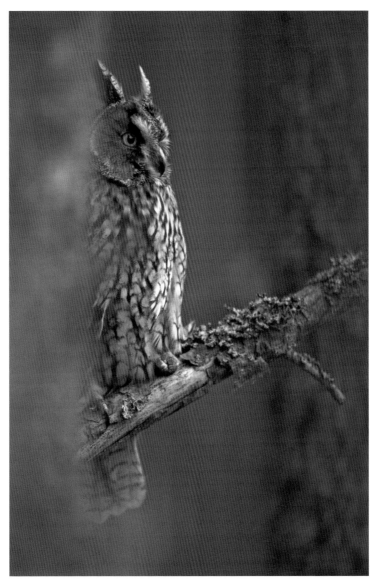

As with other owls, the presence of long-eared owls can easily escape detection. They nest in thick woodland—often using an old crows nest—and are almost entirely nocturnal, hunting over open meadows, moors or marshland for voles or mice. The male's territorial call is a low, pumping 'hooo', reminiscent of blowing into an empty bottle. (PC)

The rapidly dwindling numbers of capercaillie in Scotland is a high-profile and complex conservation issue. Human disturbance is one of the reasons cited for their decline, hence photographing these enigmatic birds in Scotland has inevitably become difficult. This handsome male was photographed in the spring when the birds are at the height of their courtship display. Engrossed in attracting female attention, his frantic activity carried on well into the night and having eventually run out of steam, he chose to roost just a few metres above my tent. (PC)

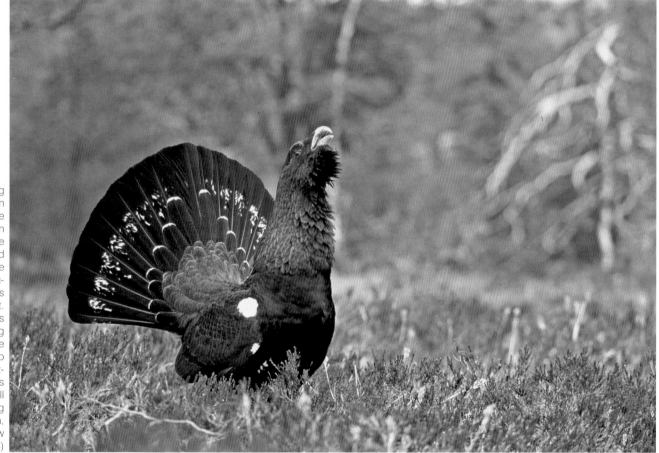

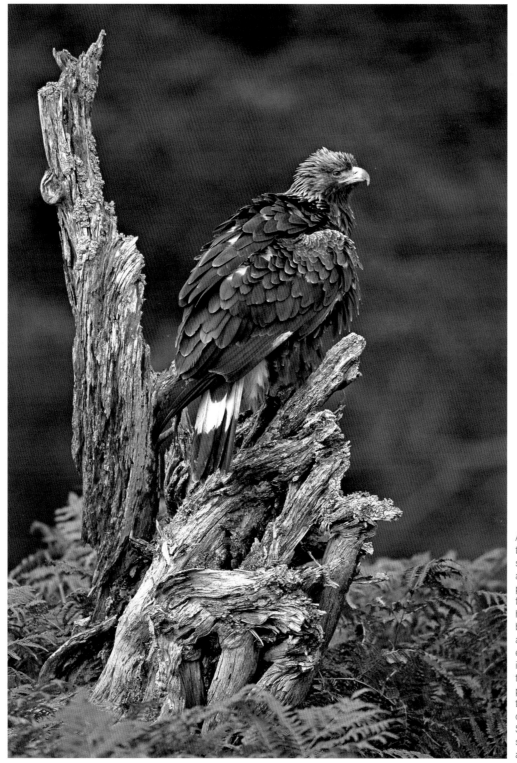

Although golden eagle territories overlap and their size is dependent upon food availability, an average eagle pair might have a range of fifty square miles. They hunt high on the mountain tops but the pine forest edge and open ground can be equally productive. Their incredible eyesight enables them to pick out potential prey from a distance of over two miles. These magnificent birds, so symbolic of Scotland's wild places are still the subject of occasional human persecution. (PC)

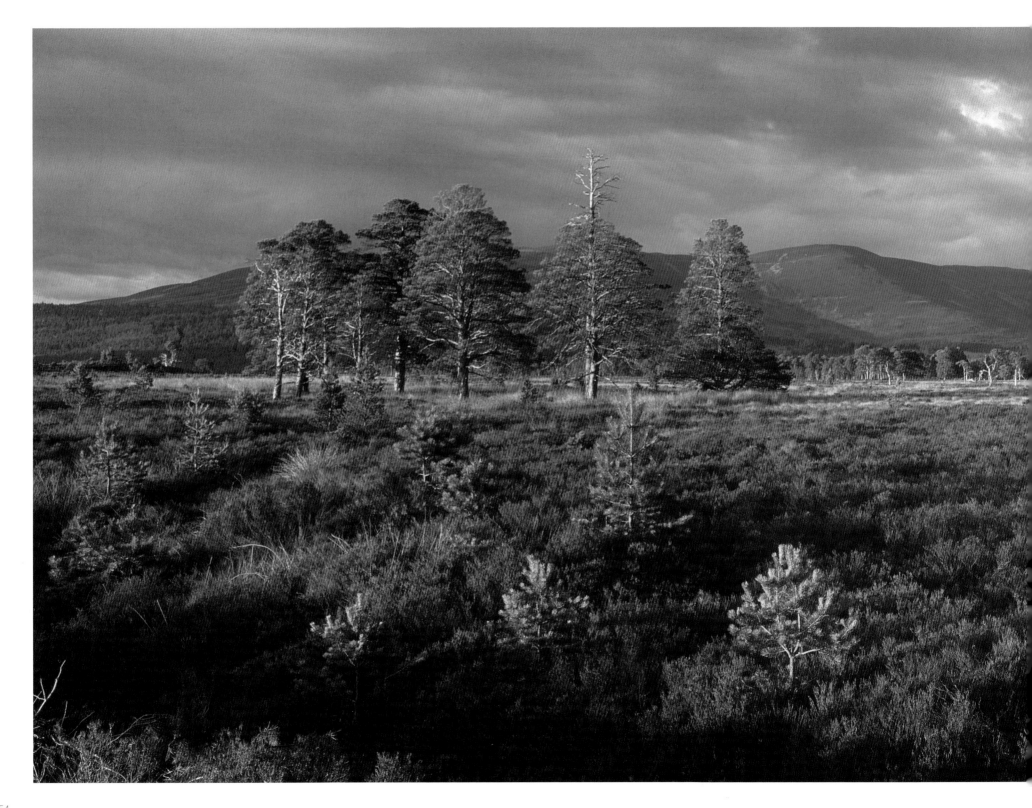

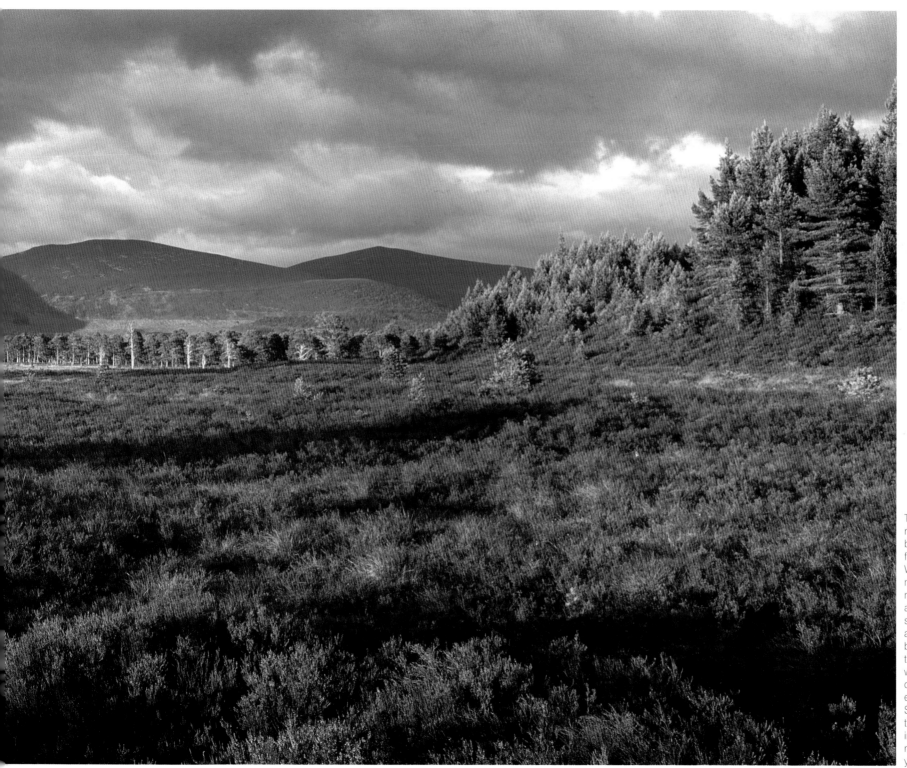

This area of open moor has retained its mature pines, but until recently showed few signs of fresh growth. With a change in management regime, vigorous regeneration is taking place as the forest of the future stakes its claim. Given time, a dense carpet of pine and birch saplings will establish themselves, some of which will be browsed by deer into contorted shapes, while others will grow straight and tall. Some of the young pines in this picture may still be looking out over the Grampian mountains three hundred years from now. (PC)

THE PURPLE FIRE OF SUMMER

We patronise animals for their incompleteness, for their tragic
fate of having taken form so far below ourselves. And therein
we err, and greatly err. For the animal shall not be measured by
man.

In a world older and more complete than ours, they move
finished and complete, gifted with extensions of the senses
we have lost or never attained, living by voices we shall
never hear.

[Henry Beston]

The intoxicating scent of honey and the panoramic vistas ablaze with ephemeral tones of purples and pinks have a romantic appeal to those who imagine our moors an untameable wilderness. Their expanse and inhospitable appearance may nurture this impression, but tamed they have been, both by nature and more significantly by economics. Characterised by the resonant 'go-back, go-back' calls of the resident red grouse, the extensive heather moorland that skirts the foothills of the Cairngorms massif has endured a historical roller-coaster of fortunes.

This dried blanket bog that submerged parts of the post-glacial forest offered an early haven for opportunistic plants and shrubs grateful to be free of the forest canopy. These open glades expanded through forest fire, storm and increasing clearance by man and the resultant embryonic moorlands attracted blaeberry, crowberry and dwarf species of willow and birch. None of these plants however, were better adapted to life on the nutrient-poor, acidic uplands than heather. The famed pink flush of late summer is attributable to the most common of the heather species, ling, derived from the Norse word 'lig' meaning fire.

Heather quickly established itself as the dominant plant of upland heath and was historically used by man for thatching, insulation and bedding. There was however, a different quality to this hardy plant that would shape its future and that of huge expanses of moorland that now frame the Cairngorms National Park.

In the late 18th and early 19th centuries, at the order of absentee landowners and Highland chieftains, armies of sheep replaced the Highland communities that lived off the land. The sheep brought with them the practice of muirburn (cyclic heather burning) to improve grazing productivity, but following a slump in wool prices, the requirements and management of the moors changed. Shepherds were replaced by gamekeepers empowered to maximise red grouse numbers for shooting.

Those with high-society connections paid handsomely to shoot grouse and anything intent on preying on this prized quarry was dispatched with impunity. With the threat of predation removed, red grouse numbers swelled and an industry thrived. It was an industry which supported not only rural livelihoods, but which nurtured a culture of species-specific management that is still in evidence today.

During the last century, a reduction in estate staff led to less intensively keepered moors and falling grouse populations. Legal protection for all birds of prey and many of the mammals branded 'grouse-killers' now confounds those already facing an uncertain economic future on the moors. This, coupled in many areas to more enlightened land management, perhaps affords an opportunity for moorlands to provide refuge for a greater diversity of wildlife. Presently, 41% of the Park is classified as moorland.

The red grouse itself is of course oblivious to the politics that surround its history. It is a sub-species of the globally widespread willow grouse, which makes its home in the transition zone between boreal forest and tundra. Willow grouse that found their way to Scotland 8000 years ago evolved not only a liking for heather but a change of plumage to russet, gold and grey, more in keeping with their new home. The red grouse of today remains closely related to its northern cousin, but is endemic to Britain.

Red grouse are dependent on heather for food, shelter and nesting sites. Regular burning creates a patchwork of heather of different ages, providing optimum conditions for these moorland specialists. In late April, red grouse are engaged in courtship and territorial skirmishes and it is at this time that they are at their most visible, the cock birds calling a resonant and repetitive warning to their rivals.

During spring the moors are transformed into a vibrant tapestry of life. Adders, newly emerged from a long winter hibernation, seek out the warmth of the sun to energise their lithe bodies. Curlew, lapwing, snipe and golden plover are amongst the waders that return from the coast, creating a cacophony of sound as they vie for territory and mating rights.

Where there is prey, there are predators. Hen harriers, short-eared owls and merlins all gravitate to heather moorland with its abundance of potential food. All three species nest directly on the ground, choosing areas of long dense heather that provides concealment for their eggs and chicks.

Merlins follow the migrational movements of their main prey, meadow pipits. The dashing slate-grey male flies fast and low over the heather tops, searching out skulking pipits as well as wheatears, whinchats and stonechats. Early in the breeding season, their presence is betrayed by their distinctive courtship calls as they spiral skywards high above their chosen nest site.

Hen harriers, named for their penchant for domestic fowl in days gone by, spend prolonged periods on the wing, effortlessly quartering their territory. The male, or 'bluehawk', is a smart silvery grey, a ghostly form gliding over the moor. His courtship display is a frenzied 'skydance' soaring high before corkscrewing earthwards in a timeless performance. The female is less pretentious and her subdued, yet intricate brown plumage is offset by a bright white rump earning her the name 'ringtail'.

During the month-long incubation of up to five eggs, the female harrier will rarely leave the concealed nest, relying instead on the attendant male to deliver her sufficient food. Their diet includes meadow pipits, small rodents, young hares, wader chicks and inevitably young red grouse.

Little sympathy is afforded to grouse predators. Poisoning and shooting incidents still occur, making headline news and evoking outrage at such wanton destruction of our wildlife. Increasing public pressure towards more severe punishment for such crimes has resulted in custodial sentences for the first time in history. Hen harriers however, together with with red grouse, remain simply pawns in the politics of land management.

At the height of summer, far above the moor, peregrine falcons stalk the skies to feed incessantly hungry chicks. A supreme hunter, a peregrine can stoop in a vertical dive at speeds in excess of 200mph, seizing a bird its own size with lethal precision. Following a slump in its numbers nationally—resulting from the effects of agricultural pesticides—peregrines have rallied over recent decades, many benefiting from areas of moorland within their territories.

Open moorland also provides hunting opportunities for perhaps the most celebrated of all highland raptors, the golden eagle. Of the 450 or so pairs which make their home in Scotland, the Cairngorms National Park supports one of the highest mainland breeding densities. The abundance of food found within the Park's mosaic of habitats suits the eagle well and they are able to prosper in undisturbed locations, preying upon foxes, deer fawns and mountain hares.

Masters of concealment and fleet of foot, mountain hares are not an easy target and are generally overlooked by anything smaller than an eagle. Although found at high altitudes, these charismatic mammals are perhaps better suited to the heather-clad moorlands. Slightly smaller than their lowland cousin the brown hare, they moult twice each year, from an almost pure white winter pelage to a sleek brown-grey that blends with their summer surroundings. Like other hare species, they can breed prolifically. Mortality however, can be high in this challenging environment and hare populations are notoriously volatile in common with other arctic dwelling species.

In the Cairngorms, moorland management is inextricably linked to red deer, our largest and most striking of all land mammals. Long since freed from the threat of natural predators and with numbers artificially sustained by some estates for stalking, the Scottish red deer population has rocketed, with current estimates ranging from 300,000 upwards. A similar area in eastern Europe, where the land lies less disturbed, might support only 10% of this number.

Fenced out from much of their natural forest habitat, red deer have adapted to life on open moorland. This harsh environment, lacking in shelter and offering meagre pickings, has resulted in Scottish deer developing to a much smaller size than their European counterparts. This impoverished state of the Scottish deer herd is condemned in some quarters and calls for extensive culling have gathered momentum in recent times. This, like so many other land-use issues, is controversial. Red deer play an important part in the highland economy, with revenue from stalking and venison sales supporting some rural communities.

As the rich purple of summer slowly fades, the seed-heads of the ling ripen, attracting parties of bullfinches and linnets twittering on the breeze. Waders have long since returned to the coast with a new generation in tow. Chats and pipits move south, accompanied by ever-attendant merlins and the moor, along with the resident grouse and mountain hares, settles down for the onset of winter. Come February, the moor will be cloaked in a pall of smoke as the annual ritual of heather burning lays the foundation for new life. (PC)

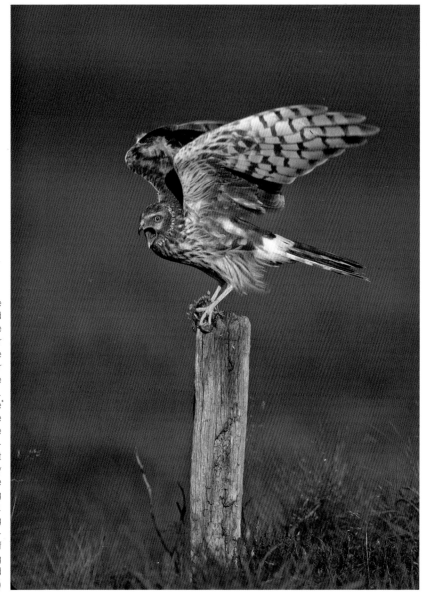

In the first light of dawn, the female hen harrier alighted from her nest where she had been brooding her four chicks. Silently, she made the short flight to her favoured perch, just as she had on previous mornings. Here she spent her time preening, while her mate was busy scouring the moors for prey. Upon his return the female rose to meet him and, in an extraordinary feat of aerial acrobatics, she flipped over, talons facing upwards to grasp the prey. Returning to her plucking post, she seemed angered by the males lack of urgency to hunt, screaming at him with her wings held aloft. (MH)

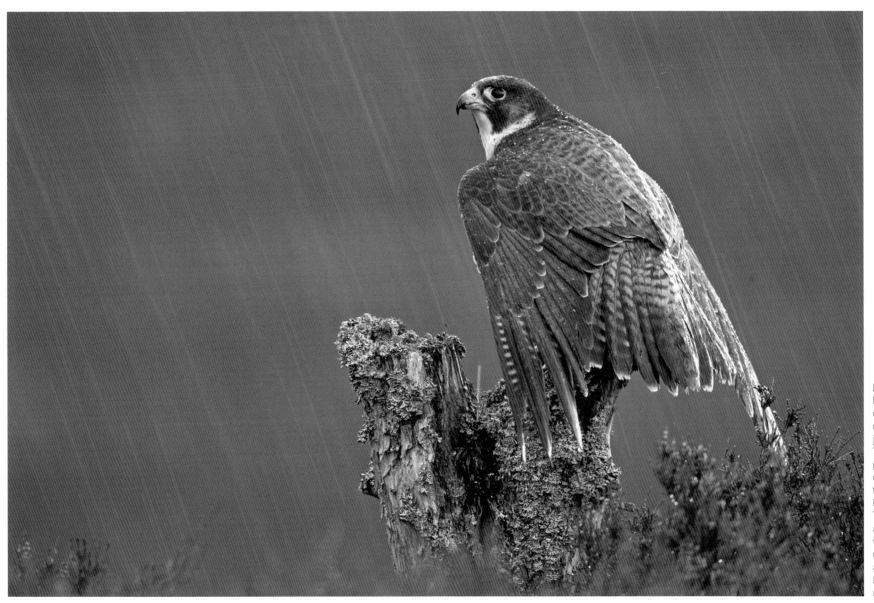

Following a chequered history, peregrines have recovered in numbers and are currently breeding in the majority of their former haunts. This reverse of fortunes has prompted some pigeon fanciers to call for a reduction in their numbers, following the loss of highly prized birds. Their liking for pigeons led to a similar conflict during the war years, when a number of peregrines were shot as a precaution against the loss of pigeons carrying vital messages. (MH)

Flowering in June and July, bell heather comes into blossom much earlier than its more widespread cousin, ling. With a preference for dry sandy soils, bell heather can often be found growing on exposed banks with a sunny aspect. Its vivid purple flowers attract a range of insects including honey bees. These industrious insects move from flower to flower, pollinating the plant in return for a sweet nectar which is responsible for the delicious heather-scented honey produced locally. (MH)

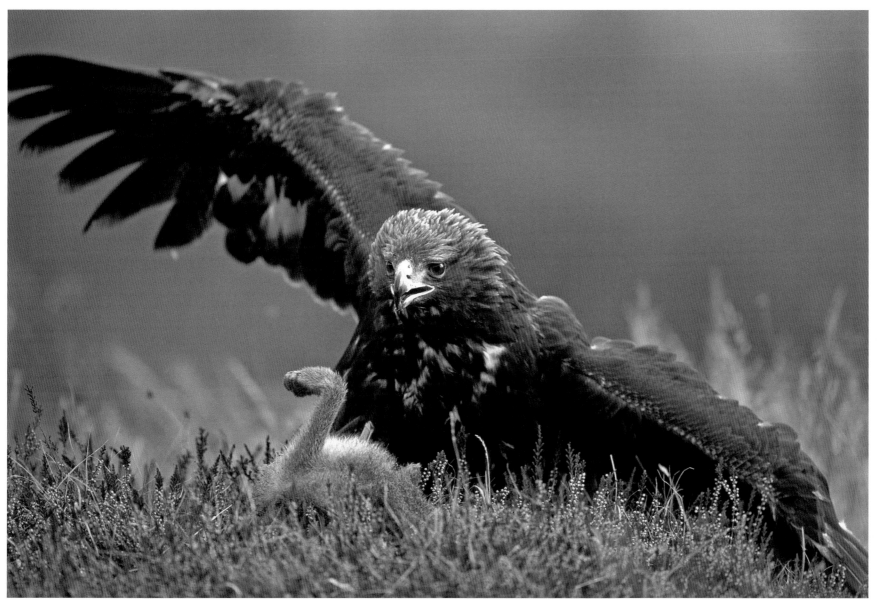

High in the sky, almost invisible to the naked eye, a golden eagle soars on broad wings over its territory. For the most part, the eagle is content to watch over her kingdom, but in an instant her attention is drawn to a mountain hare feeding on fresh heather shoots. She loses height quickly, using the slope of the hill to conceal her attack. Now only a few metres above the ground, she closes in on her quarry. In a matter of seconds she is upon her prey, which bolts for freedom at lightning speed, but the eagle moves too quickly and with outstretched talons she dispatches the hare with lethal precision. (MH)

April is the height of red grouse courtship activity, the handsome males resplendent in their russet plumage with bright red wattles over their eyes. Their territorial call—a far-reaching, nasal delivery which winds into a hoarse warning to 'go-back, go-back'—is delivered proudly from atop a prominent boulder. The more demure female (facing page) has a beautiful cryptic coloration of shades of brown and is well camouflaged amongst the heather. (MH & PC)

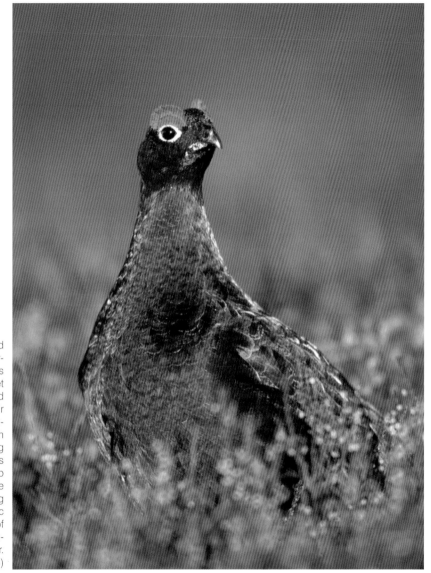

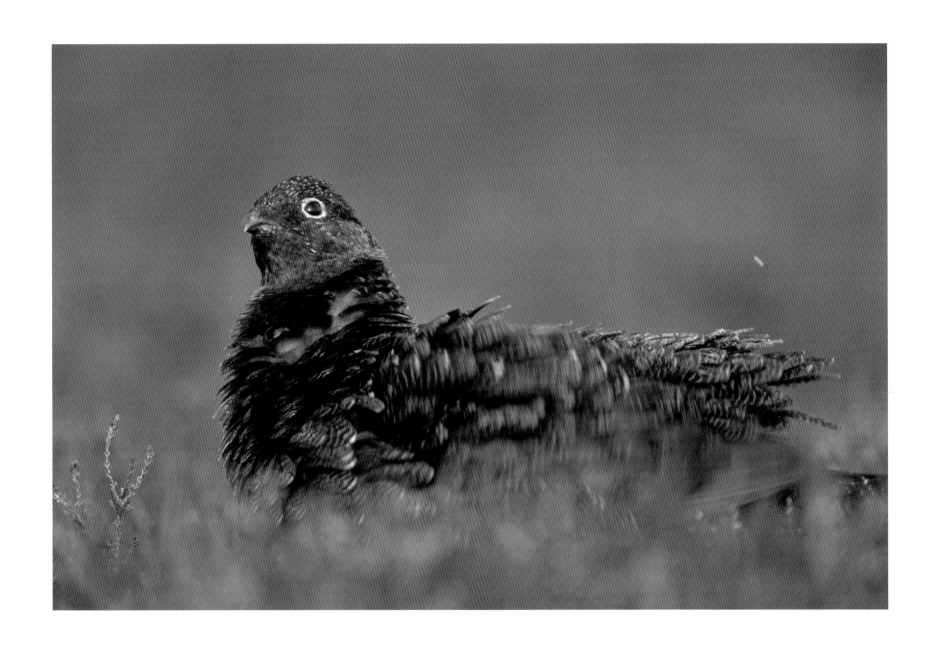

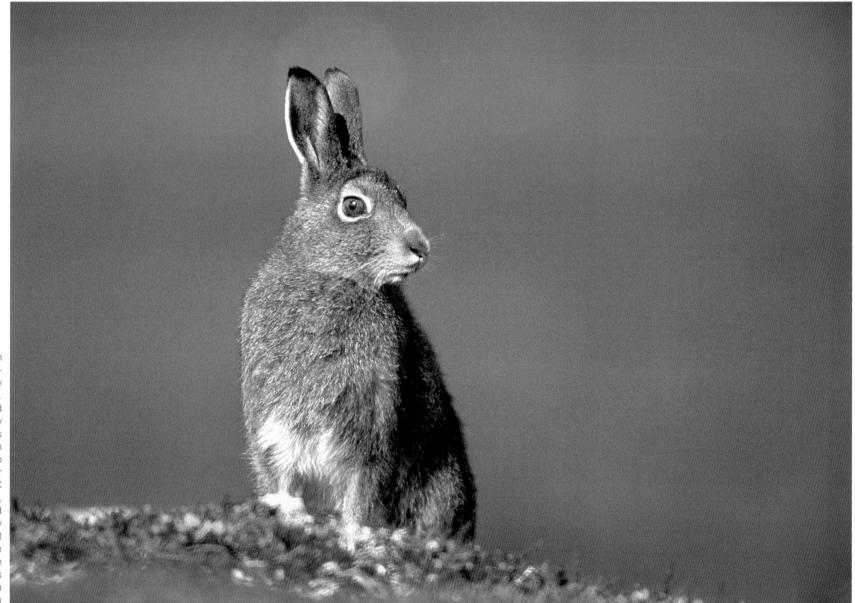

In some areas, mountain hares are shot commercially, but they are generally regarded as small game. They are often controlled on grouse moors, as they carry ticks and parasites which, when passed on to the birds, can lead to a dramatic crash in their population. Under the EC habitats directive (1992), mountain hares are listed as a species 'of community interest'. This means that certain methods of capture are prohibited. Very little scientific information exists on long-term changes in hare populations. (PC)

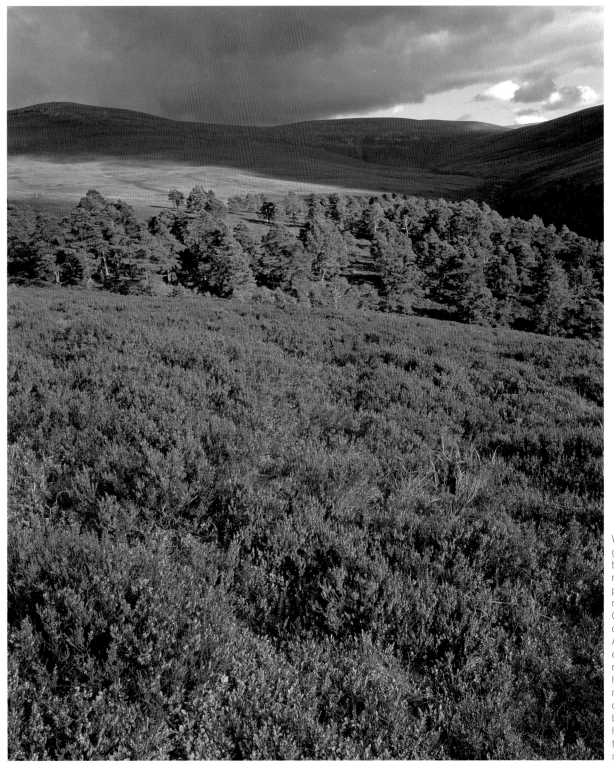

Where heather is left to grow, it quickly becomes thick and straggly and reverts to scrub woodland pioneered by birch and rowan. This area of lower Glenfeshie is a link in the chain of forests from north Abernethy to Glenfeshie estate. To initiate forest regeneration, deer numbers have been reduced and the mature pines in the middle distance will act as a seed bank for new growth. One hundred years from now, this will no longer be open moor. (PC)

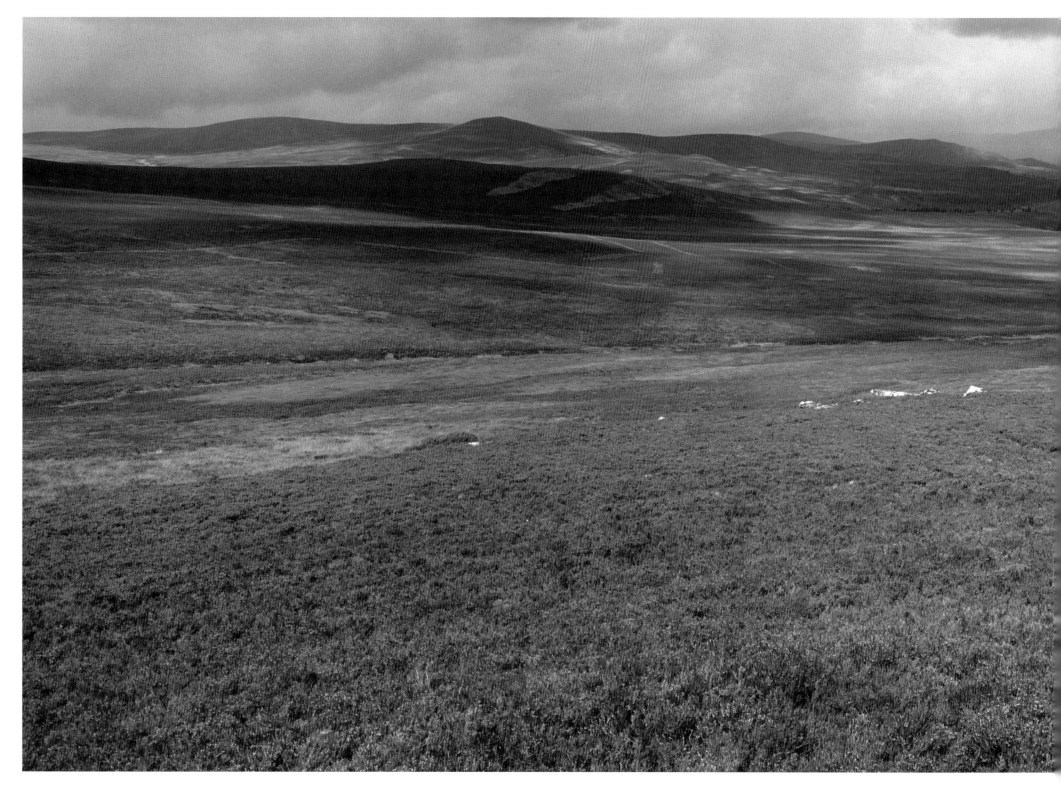

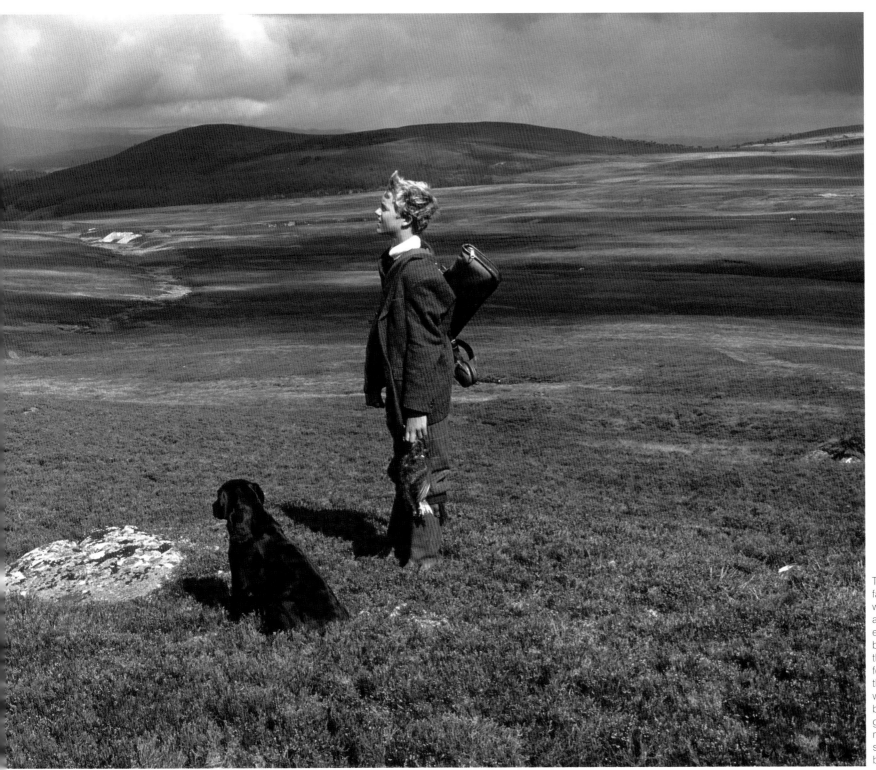

This young man and his faithful black labrador, Coco, was on his first shoot on a local estate. The huge expanse of moor that lies before him is impressive and the flowering heather makes for an iconic landscape of the eastern Highlands. If this was forested, as it would be naturally, the appeal of grouse shooting on Scottish moors would be lost and so too, would the revenue it brings. (PC)

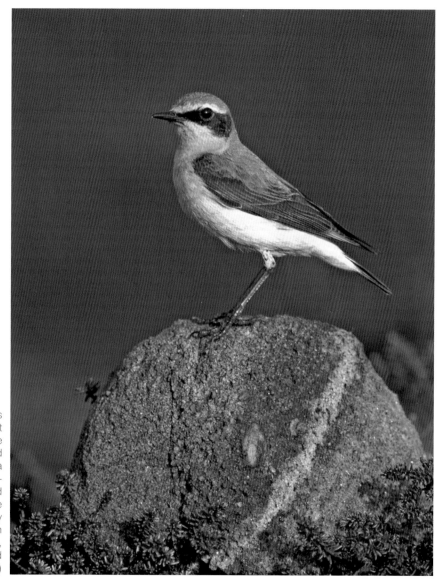

Wheatears favour habitats that contain areas of short vegetation where they are able to search for food on the ground. They are a versatile species, breeding from the farmland fringe to the summits of the Grampian mountains. They nest in holes, most often amongst or under rocks, but will also use abandoned rabbit burrows. (MH)

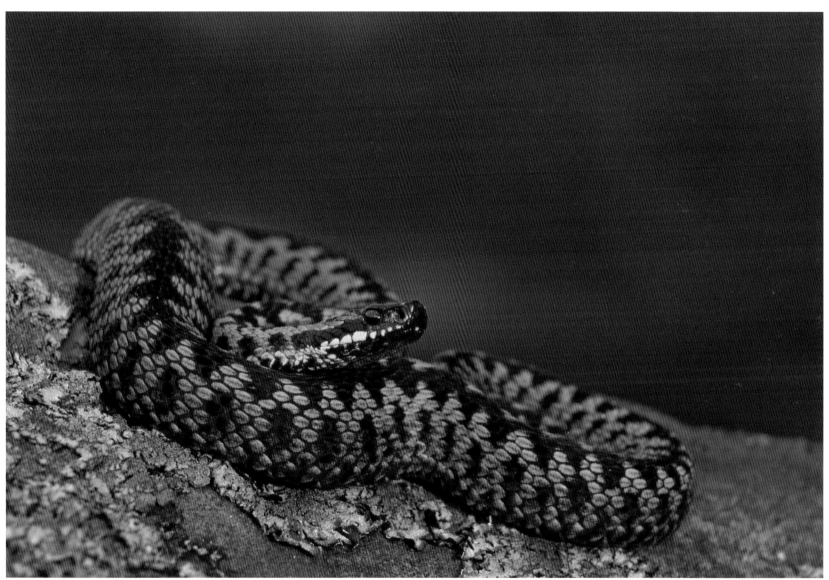

As Britain's only venomous snake, adders are feared by many. They are however, naturally wary creatures, capable of sensing even the slightest of movement through vibration. This enables them to hunt prey effectively as well as evade detection by humans. In their moorland habitat, their main prey are common lizards and where there is an abundant supply, adders maintain good populations. They are most likely to be seen early in the morning, basking on a rock or amongst dead bracken. (MH)

Buoyant in flight, short-eared owls hunt the rough grasslands of the moors on giant moth-like wings, hovering momentarily before dropping like a stone onto their prey. During the breeding season, the male bird hunts exclusively and the female remains at the nest to brood the chicks. From my hide close to a secluded nest site, I had a privileged insight into their world. The chicks were of different ages ranging from only a few days old up to almost two weeks. For the most part, the youngest chicks remained out of sight, snug beneath their mother while the eldest were akin to streetwise teenagers, hanging around on the edge of the nest. (MH)

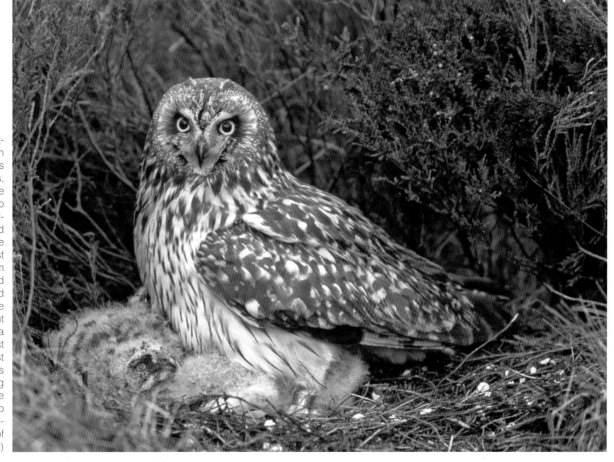

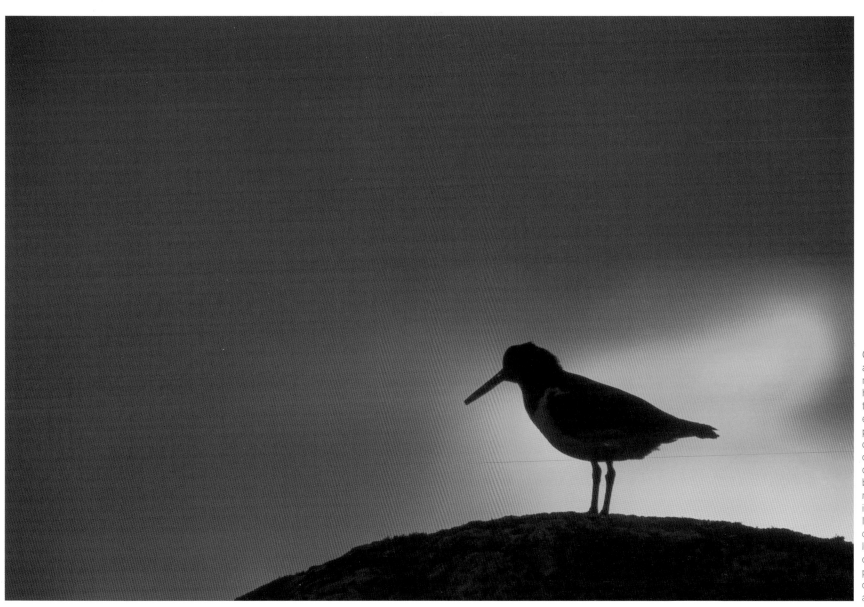

Oystercatchers are adaptable birds, finding suitable nest sites in a wide variety of habitats, from open meadow to shingle river beds and even roadside verges. Whilst photographing red grouse one evening in May, this oystercatcher expressed its displeasure at my presence by its agitated piping from a nearby hummock. Realising I was close to its nest, I moved away and carried on working elsewhere. On leaving the moor at dusk, I drove back past the same point and momentarily the oystercatcher took up guard against the setting sun. (PC)

Grouse shooting brings an estimated £15m to the rural Scottish economy each year and many estates are financially dependent on this bountiful but short-lived revenue in late summer. We are efficient hunters, organised and well equipped, capable of felling an estimated 250,000 red grouse annually across Scotland. Competition from other species for this particular prey item is largely unwelcome on most moors. (PC)

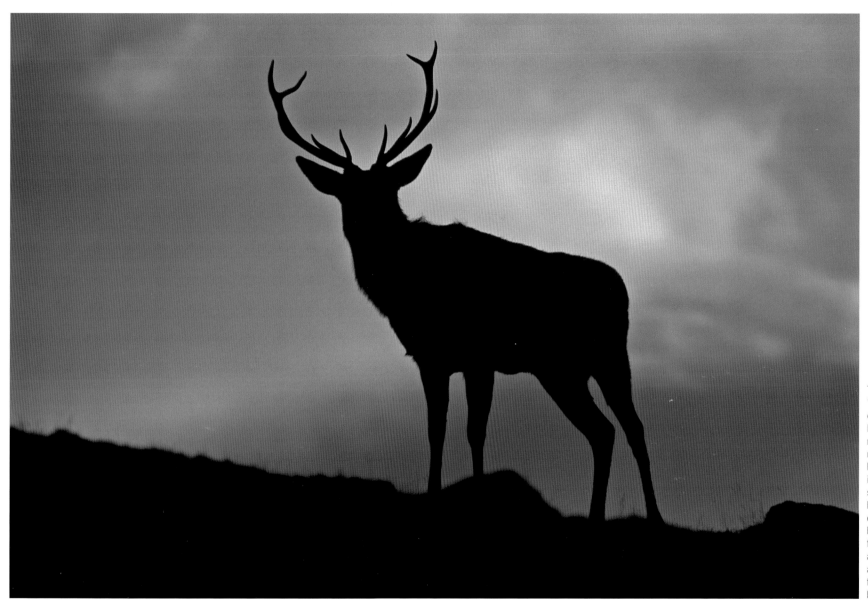

The familiar outline of 'The Monarch of the Glen' eyes me suspiciously as a long winter's night draws near. At this time of year, red deer would previously have sought shelter deep inside the forest, but this stag, along with many of his kind, will face the night on the open hill excluded by an endless line of high fencing. Exposed to rain and cold and sustained on a low nutrient diet, many will face starvation and disease before winter is out. (PC)

AN ARCTIC LEGACY

Thousands of tired, nerve-shaken, over-civilised
people are beginning to find out that
going to the mountains is going home; that
wilderness is a necessity;

and that mountain parks are useful not only as
fountains of timber and irrigating rivers, but as
fountains of life.

[John Muir]

Sheltering in a snow pocket from a driving northerly wind, a male ptarmigan looks out across a hostile mountain landscape that has changed little in ten millennia. Subjected to sub-zero temperatures for more than 80 days each year and with some of the highest wind speeds recorded in the country, the plateaux of the Cairngorms massif remain a challenging environment for all forms of life.

The characteristic mountain range that we know today has been fashioned by geological forces and climatic changes sculpting and moulding the land. This unique landscape, released from the steely grip of ice, contains four of the five highest peaks in Britain and forms the most extensive mountain system in the country. Characterised by a broad granite plateau, deep corries and glacial-scoured glens, the Cairngorms range began life over 400 million years ago as melted rock deep within the earth's crust.

On summits such as Beinn Mheadhoin, Bynack More and Ben Avon, towering granite tors—weather sculpted stacks of deeply rutted rock—reach for the sky. Other ancient geological features suggest that the Cairngorms were previously dominated by broad plateaux, rolling hills and shallow valleys. Whilst this broad outline is still evident today, the deeply carved troughs of Loch Avon and the Lairig Ghru bear witness to glacial erosion. Ice, wind and water remain at work today: elemental forces of nature which determine the very existence of mountain life.

In parts of the western range, there remain rare examples of a natural treeline where altitude and soil conditions have prevented further tree growth. Here, the pines and birches are stunted and contorted as they battle for survival. Moving upwards, life gets tougher, temperatures cool and the soil becomes thinner. The plant communities at these higher altitudes have evolved naturally, unaffected by human influence and provide a rare opportunity to view a truly wild landscape. Heather dominates up to around 900m, yielding to a dwarf heath of low lying vegetation that is able to withstand snow cover, wind, frost and drought.

Of plants, only the hardy survive the conditions on the high plateau. Arctic-alpine specialists prevail, such as the brightly col-oured moss campion and trailing azalea and, on the base-rich rocks, mountain avens, yellow mountain saxifrage and alpine cinquefoil.

Bird life is equally sparse and specialised. Even in summer, when a few hardy wheatears, ring ouzels and meadow pipits venture into the hills, the resident ptarmigan, superbly adapted to this arctic habitat, will be the bird most commonly seen. Within Britain, ptarmigan are exclusive to Scotland's mountain ranges, with the core population within the Cairngorms massif.

Feathered legs and a well insulated coat help to maintain the ptarmigan's body temperature during the winter months. In the gale-driven blizzards that rage across the high tops, they seek out shelter among boulders and often resort to digging out snow holes, which provide insulation from the cold. The weather is not the ptarmigan's only enemy: golden eagles and peregrine falcons patrol the mountain skies throughout the year; foxes and wildcats will also take ptarmigan given the opportunity.

To mitigate the aerial threat, ptarmigan have evolved a strategy of almost continual moulting, adopting different plumages depending on the season. In autumn a mottled grey—a perfect match to the granite rocks amongst which they hide—makes them almost invisible. In early winter, triggered by falling temperatures and shortening day length, they moult to pure white. They change again in spring as they prepare for the breeding season, the female taking on a cryptic plumage of browns and golds, affording her superb camouflage whilst incubating her clutch.

For much of the year, ptarmigan live quiet, unassuming lives, relying on their colouration to avoid detection. On fine mornings in early spring however, things change. Like their lowland cousins the red grouse, the highly-charged males proclaim their presence from prominent boulders, their deep croaking call echoing around the shadowed corries. Loss of inhibition in the desire to reproduce greatly increases their vulnerability to watchful predators.

The ptarmigan's springtime exuberance is shared by a small breeding population of snow buntings, which also thrive in this arctic environment, the dapper black and white males delivering their lark-like warble from a rocky perch high on the corrie wall. On the rolling alpine meadows, the dotterel, a brightly-marked member of the plover family, conceals its eggs in a simple cup of moss and lichen. These birds winter below the Atlas mountains in North Africa, migrating in spring to nest in the far north of Scotland and Scandinavia.

The highly specialised wildlife of the mountains has evolved and adapted slowly over time, but significant changes to this ancient landscape have been brought about only recently—by humans. Skiers, walkers, climbers and naturalists flock to these hills in ever greater numbers, to test their skills in one of our truly wild places. Whilst sustaining local employment, visitors bring pressures to bear on this fragile environment. The skiing industry perhaps remains the most controversial of recreational pursuits, but all visitors to the mountains have an impact, however small.

Since the opening of the White Lady chair lift in 1961, Cairngorm has remained the most extensive ski development of the three facilities within the National Park. The recent replacement of the main chair lift with a funicular railway was debated and hotly opposed by many conservation groups, who argued that this convenient means of ascent would bring yet more visitors to the tops, causing further damage and placing inexperienced people in an unforgiving environment. Some of these fears were allayed when a 'closed system' was agreed for the top station preventing walkers leaving the confines of the visitor centre. For many, the scar that blights the northern face of the Cairngorms is itself a gross intrusion into this otherwise wild area. Opinion on further development remains divided.

Long term research has shown that ptarmigan in particular have been affected by ski development, many birds flying into snow fences and ski wires. Increased human litter has also encouraged scavenging crows to the high tops for the first time, keen to explore rubbish bins and not averse to ptarmigan eggs. Since crows have been controlled, ptarmigan have returned to breed in the ski area, perhaps illustrating that development per se need not always have a negative impact on wildlife, but that the thoughtless actions of a minority of people often does.(MH)

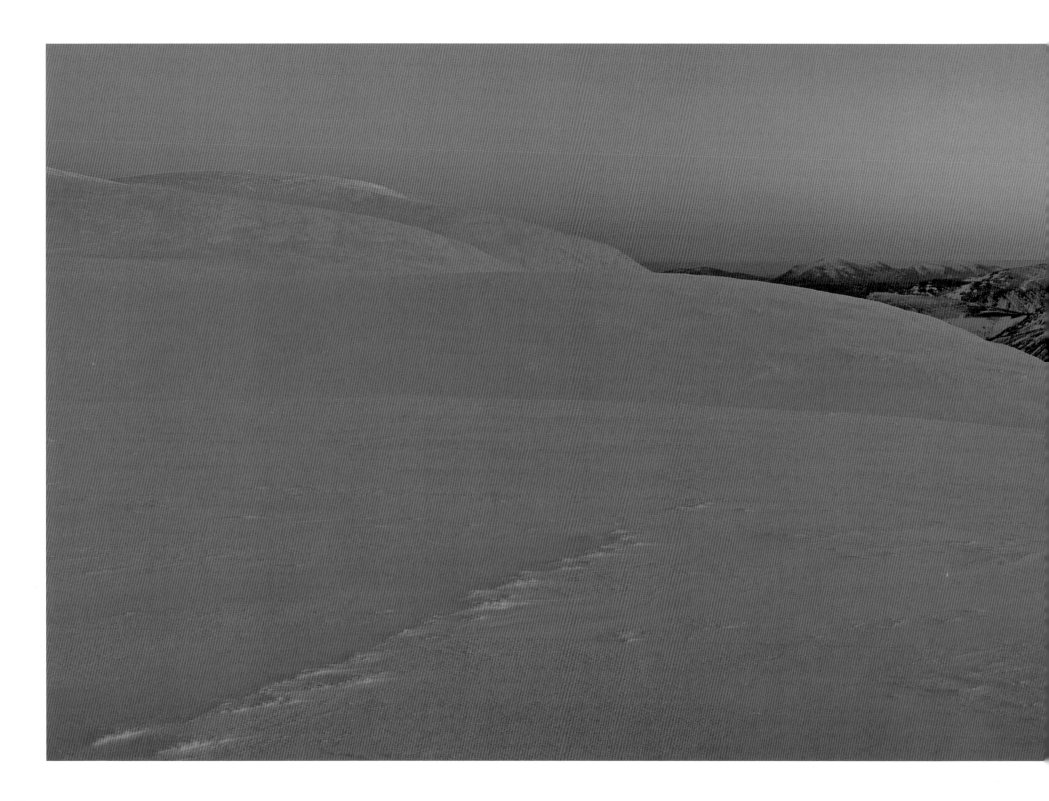

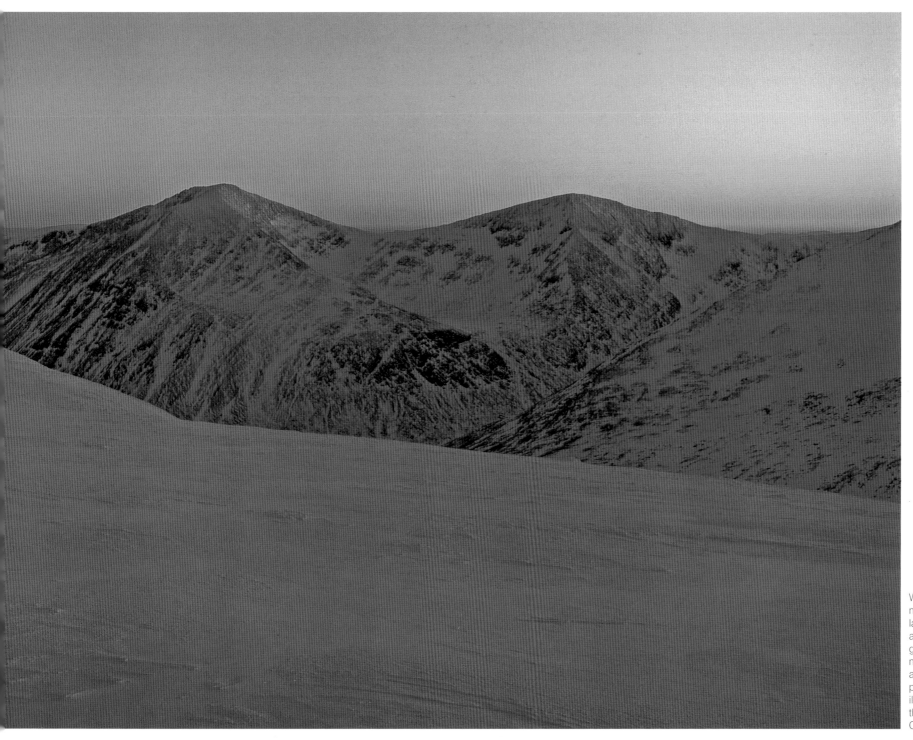

Winter photography in the mountains can be spectacular, but requires much effort and is not without its dangers. On this late evening in mid-March, the snow field across Cairn Lochan turned pink as the last rays of light illuminated Beinn MacDuibh, the highest mountain in the Cairngorms range. (MH)

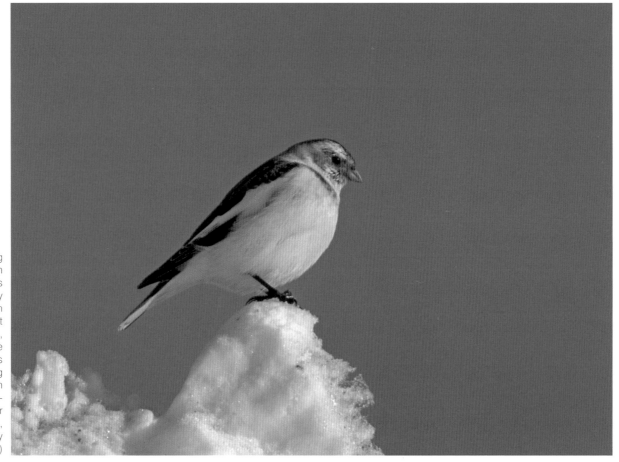

With the distinction of being the hardiest passerine in the world, snow buntings breed in the most northerly arctic regions. The Scottish population, which is thought to number around fifty pairs, has its stronghold within the Cairngorms and represents the most southerly breeding population in Europe. In winter, small flocks scavenge for food around the car parks of several ski centres, where they can be very tame. (MH)

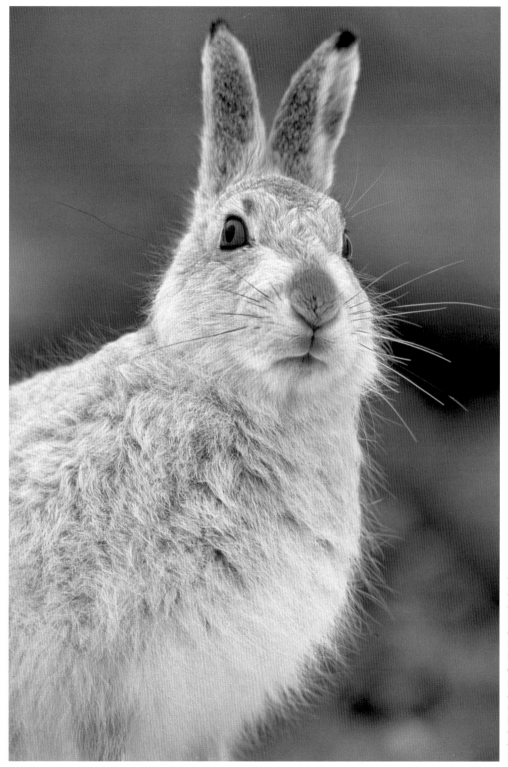

Mountain hares are believed to be the same species as arctic and greenland hares and are our only native. Here, they are associated with upland moor and mountain foothill, rather than boreal forest, which they frequent across much of their range. In the lower Grampians, mountain hares make use of the shelter afforded by the extensive boulder fields, which is where I found this surprisingly confiding individual. (PC)

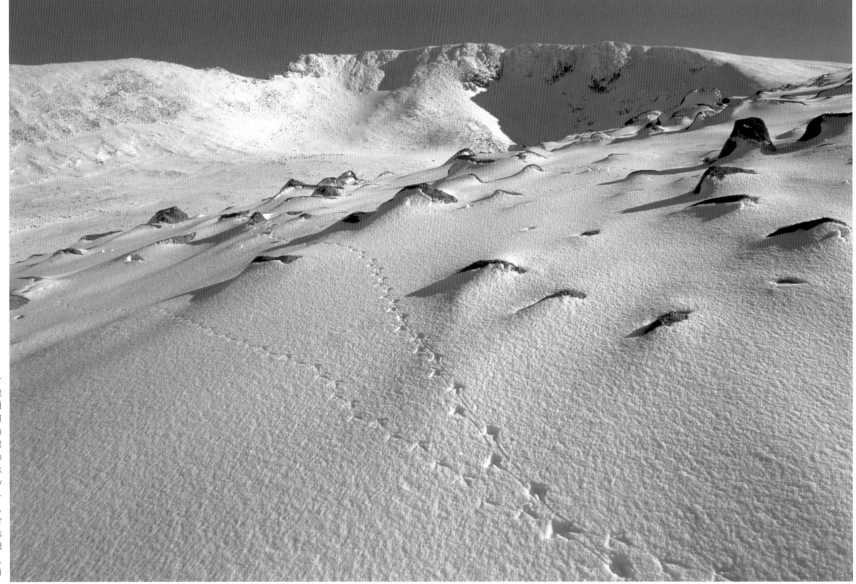

Ptarmigan are one of four grouse species resident within the Cairngorms and by far the hardiest. As hill walkers will testify, ptarmigan can be incredibly tame but equally elusive. On this crisp day in February, I was struck by the irony that all day ptarmigan had been conspicuous by their absence, yet here were their clear tracks etched on a canvas of virgin snow, discovered as I retraced my own steps, homeward bound. (PC)

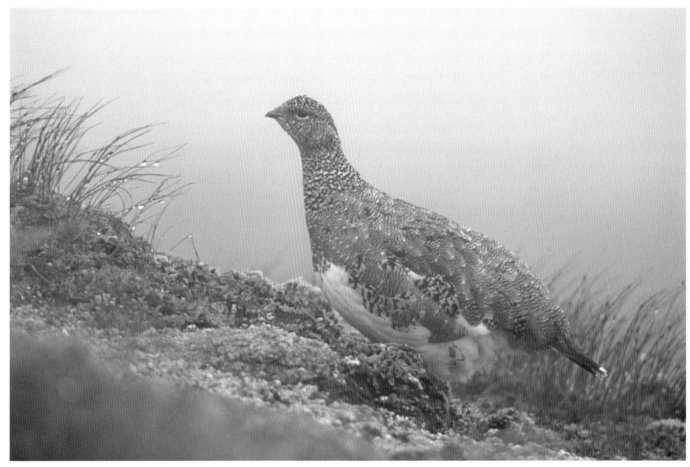

Cloaked in hill fog for the entire day, my search for Ptarmigan took me on a fruitless circumnavigation of the Cairngorm summit until I stumbled across a family party close to the aptly named Ptarmigan restaurant. Crawling on my stomach, I inched closer to this female as she busied herself feeding on fresh shoots. The soft light and dew-laden vegetation articulated the mood of the season. (PC)

Dotterel are unusual in the bird world, in that the female (pictured here) is more brightly coloured than her mate and takes the lead role in courtship displays. Once the eggs are laid, the male is responsible for incubation and tending the chicks. Research has shown that some females laying eggs in Scotland move on to Scandinavia, where they lay a second clutch and in so doing help to ensure the proliferation of their genes. (PC)

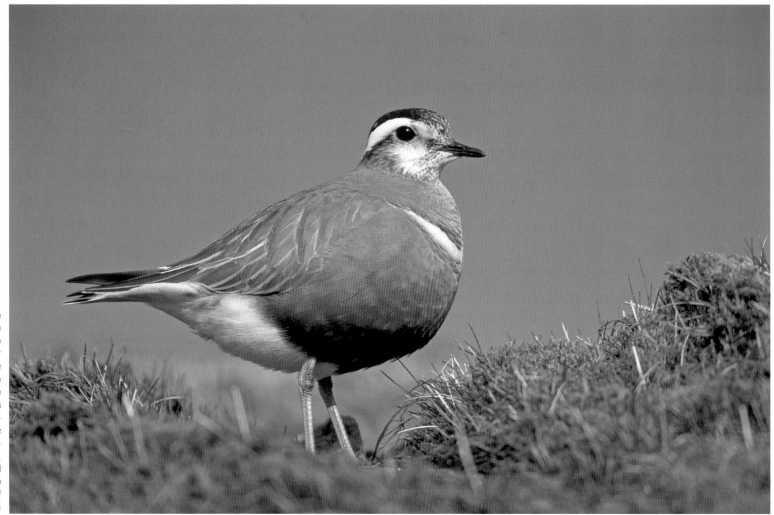

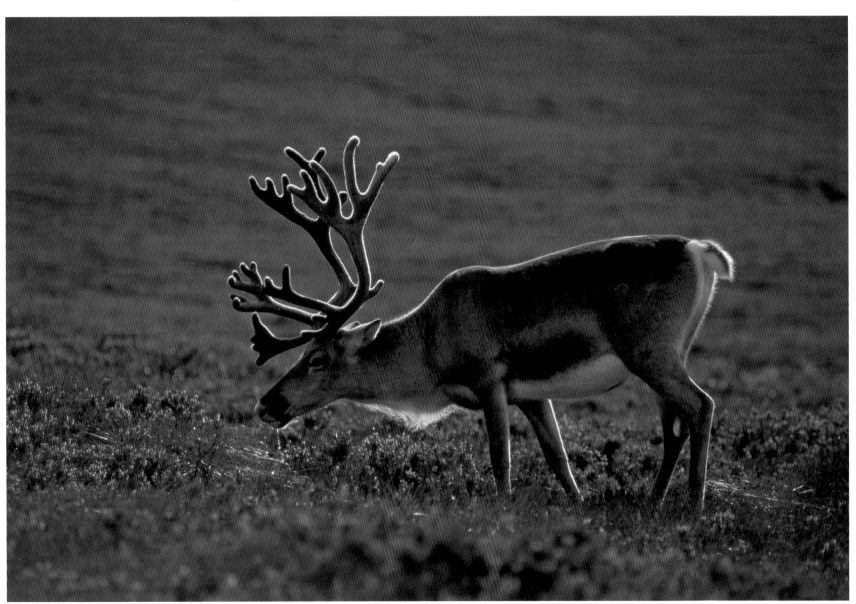

Referred to as caribou across North America, reindeer are one of the most widespread mammals in the northern hemisphere. The reindeer that roam freely across the western Cairngorms are part of a privately owned herd based at Glenmore. Since their reintroduction in 1952 by a Swedish reindeer herder Mikel Utsi, the herd, which now numbers around 150, has provided many thousands of visitors with a close insight into the ecology of this fascinating native. (PC)

In midwinter, ptarmigan sport a pure white plumage, but by the end of February many birds have already begun to sprout the grey feathers of spring. To record them in their winter finery, I ventured into the northern hills in late January. The short days of winter restrict the availability of light even at altitude but this handsome male took the opportunity of a rare clear day to signal his territorial rights. (MH)

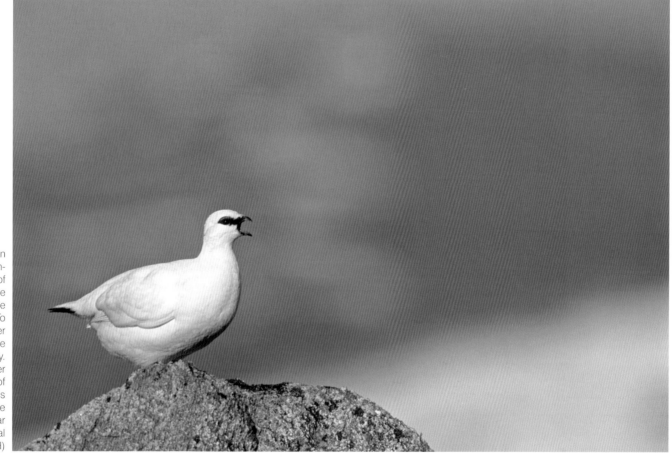

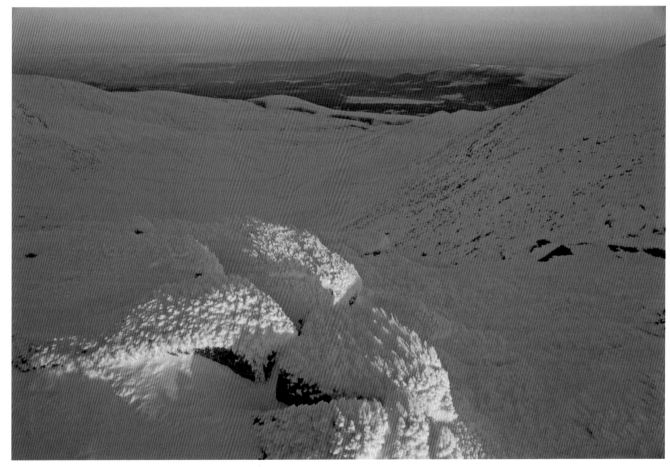

At five in the morning, the clear night sky tempted me begrudgingly from my bed. As I trudged through deep snow into the northern corries, my path was lit by the pale glow of dawn. I had a composition in mind, but the sky to the east was clear and uninspiring, the veil of cloud hanging over the Monadhliaths to the west providing more colour. I was in position just seconds before the first rays of light cast their magic onto these snow sculpted rocks. (PC)

RIBBONS OF LIFE

A lake is the landscape's most beautiful and expressive feature.

It is earth's eye, looking into which the beholder measures the depth of his own nature.

[Henry David Thoreau]

Perched atop an aged, gnarled pine, a male osprey stares at the still water below, his gaze alert to the slightest of movements. The small lochan has fallen flat calm in the tranquil air allowing him the rare privilege of a clear view beneath the surface. His prey—primarily trout—are unaware of his presence, giving him the advantage. Nevertheless, he must bring all of his skills to bear if he is to secure his prize. Instantly, he launches into flight, steadying himself into a hover before folding his wings and plunging with outstretched talons into the frigid water.

For several seconds he struggles to regain his composure, wings beating hard to lift his drenched frame clear of the water, the floundering trout hampering his efforts. Finally, he is airborne, a blur of water droplets raining down, the trout firmly clasped in a single talon. As he gains height, his other leg takes its share of the load, steadying the fish and preventing its bid for freedom. It is several miles back to his nest, high in a Scots pine, where his mate waits patiently for his return.

Ospreys are a high-profile species. Each year, over 35,000 visitors pass through the RSPB's famous osprey centre at Loch Garten. The internet carries news of satellite-tracked birds on migration and national television covers the success or otherwise of the breeding season. As a species, ospreys are widespread, occuring in high numbers in places such as Florida where they nest on artificial platforms in people's gardens. But in Scotland, they have become a beacon of hope, a symbol of more enlightened times. Like some other birds of prey, they were hunted to extinction in this area in the 19th century but ospreys recolonised in the 1950's. From these early pioneers, the osprey population has flourished and today there are around 160 pairs in Scotland with the core of the population in the Cairngorms National Park.

Ospreys are dependent on clean water and are linked inextricably with the web of life that is found beneath the surface. The fuel which sustains this complex ecosystem begins its journey on the high plateaux, cascading down through burns and rivulets into the myriad of tributaries of the main arteries of the Dee Don, Spey and Tay. These ecologically rich rivers, which drain the high montane, are largely unpolluted and along with the extensive network of lochs and lochans, are internationally recognised for the wildlife species they support.

By their very nature, these habitats are in constant flux. Periods of heavy precipitation or snow-melt dramatically increase water levels on some rivers, leading to flash flooding, severe bank erosion and even re-routing sections of the water course. These regular meteorological events shape the regions wetlands, creating new habitats and changing others.

Many of the Cairngorm rivers are relatively shallow and fast flowing over gravel, shingle and rock, a habitat that supports a limited but specialised range of species. Most revered is the Atlantic salmon or 'King of Fish'. Not only are salmon a major contributor to rural economies but they play a vital role in the overall ecology of our rivers and are an important indicator of their cleanliness.

The epic migration undertaken by salmon leads them on an arduous journey from the river in which they were born, to their feeding grounds around Greenland and the Faroes, where they remain for one to two years. Then, with a compelling urge to breed they make the return voyage, locating the mouth of their home river—most probably by the chemicals in the water. After travelling upstream without feeding, they lose around 40% of their body weight, but somehow find the strength to negotiate crashing waterfalls more than three metres in height, before finally reaching the spawning grounds of their birth. Having secured the future for another generation, the vast majority die, providing rich pickings for otters which in days gone by, would have been joined in late summer by wolves and bears.

Equally fascinating is the life cycle of the freshwater pearl mussel, once a common inhabitant of many of Scotland's rivers. Following historical over-exploitation of their valuable pearls, they are now chiefly restricted to the Highlands. They live in the sand or fine gravel of fast-flowing rivers that are free from pollution and have developed an ingenious means of reproducing. In early summer the female pearl mussel releases between one and four million fertilised larvae, almost all of which are swept away and die. The fortunate few are inhaled by young trout or salmon and attach themselves to the gills of their host. After almost a year, the larvae drop from the gills and settle onto the river bed. Those that land bury themselves in the sediment where they can live for up to 100 years, reaching sexual maturity at around the age of 15.

Many of the Park's larger lochs such as Einich and Muick, are oligotrophic—acid in nature and poor in nutrients. The ecology of many of these lochs has not changed significantly since the last ice age, and supports genetically unique fish species like Arctic charr as well as specialist insects such as the white-faced darter dragonfly.

In spring, many of the lochs, pools and rivers of Strathspey reverberate to the calls of goldeneye, a rare, northern-breeding duck. With the explosiveness of a coiled spring, the male throws back his head, his bill pointing upwards, simultaneously kicking the water with his bright orange feet. This extravagant courtship display is a recent phenomenon in the area. Although previously a regular winter visitor to the Cairngorms, goldeneye first bred in 1970 in a nest box erected by the RSPB some ten years earlier, a box intended to replicate their natural tree-cavity site. The original pair bred again the following year, and there followed a rapid colonisation to well over 100 pairs currently breeding in the Park. The nest boxes are also used by jackdaws, tawny owls and occasionally, pine martens.

Other rare northern waterfowl can also be found here. Slavonian grebes are the jewels of a select few lochans, while several high altitude pools echo to the haunting cries of a growing population of red-throated divers. Goosander are also on the increase, nesting in the holes of riverside trees. Each spring, their newly hatched chicks must take a leap of faith as they leave their birthplace to spend their young lives surfing the rapids.

In the past, extensive marshes and fen would have bordered many rivers, providing a rich habitat for a wealth of species. Most of these have now been drained for agricultural use, but of those that remain, Insh Marshes in Badenoch is of significant interest. It is the largest and one of the most species-rich flood plain mires in the country, supporting nationally and internationally important populations of wildfowl, waders and other wetland birds.

In spring, Insh Marshes comes alive with the evocative calls of breeding waders. Lapwings tumble acrobatically above their nesting grounds, their angry 'pee-wit' calls a familiar sound of the season. In contrast, curlews take a less frantic approach. On broad wings they rise slowly, their calls building to a crescendo as they reach full height, before gliding gracefully back down to earth. Oystercatcher, redshank and snipe also breed here in high numbers, adding to the vibrancy that enchants the marshes.

Many duck species are equally well represented—wigeon and goldeneye breed in significant numbers, along with teal, shoveler, red breasted merganser, goosander, tufted duck and mallard. Water rails and the rare spotted crake find sanctuary among the reed beds, which also provide habitat for grasshopper warbler, sedge warbler and reed bunting. In summer, ospreys hunt over areas of open water, while otters pursue fish at dawn and dusk.

Primarily nocturnal hunters away from their coastal haunts, otters are seldom seen, but are present throughout most of the river systems in the Park. Evidence comes in the form of footprints in mud or soft sand, as well as their characteristic spraints (droppings), which are an otter's way of communicating to others of its kind.

Long summer days herald the emergence of a variety of butterflies, damselflies and dragonflies, their fragile frames dancing and darting over wet meadows. The end of the short-lived summer is signalled by the autumnal overhead cronking of migrating geese and the atmospheric bugling of Icelandic whooper swans as they arrive from their northerly breeding grounds. Their epic journey across the North Sea ends on the Spey's winter flood-plain. They will spend their time feeding on aquatic vegetation until the lengthening days of spring cajole them once again northwards. (MH)

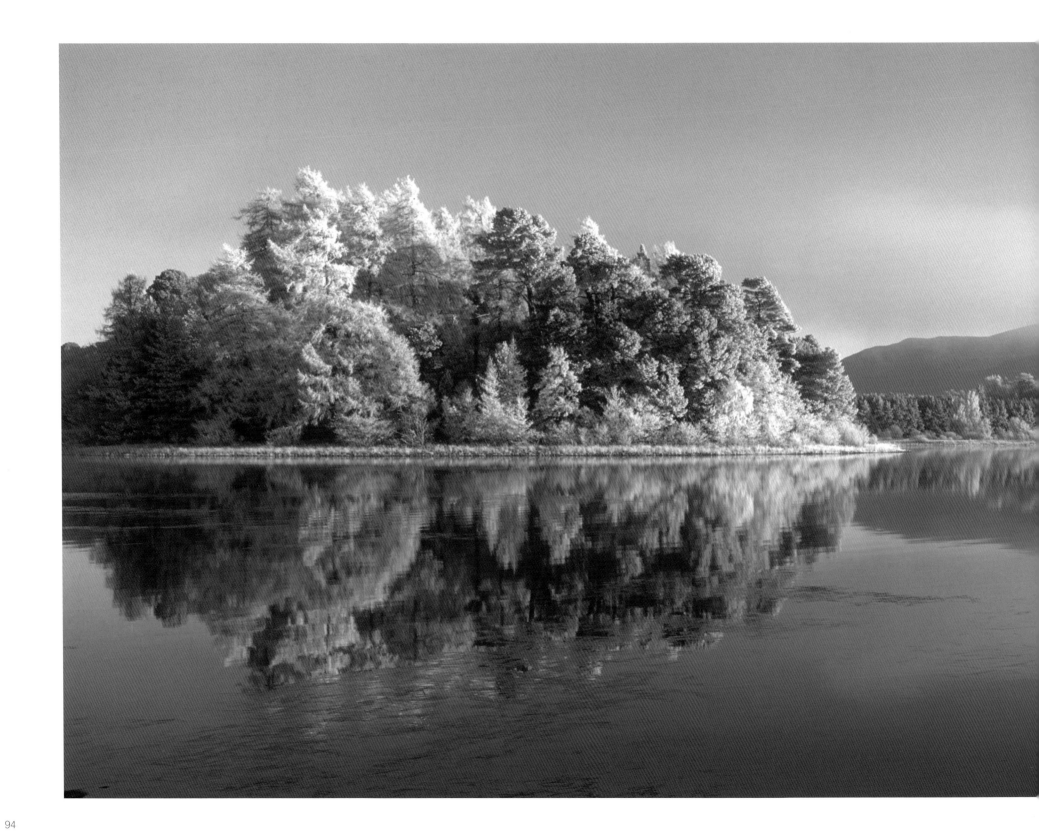

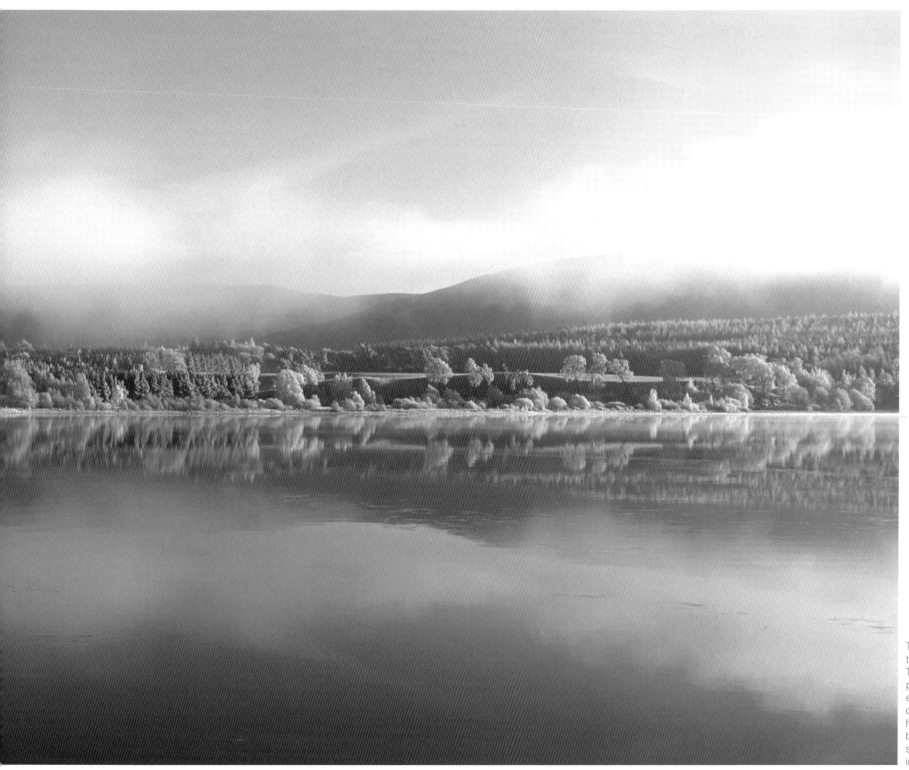

These are dawns that photographers dream about. The low winter sun gradually peeled away the layers of ethereal mist that hung over Loch Insh to reveal hoar-frosted pines and birches—ghostly figures standing stark against an intense blue sky. (PC)

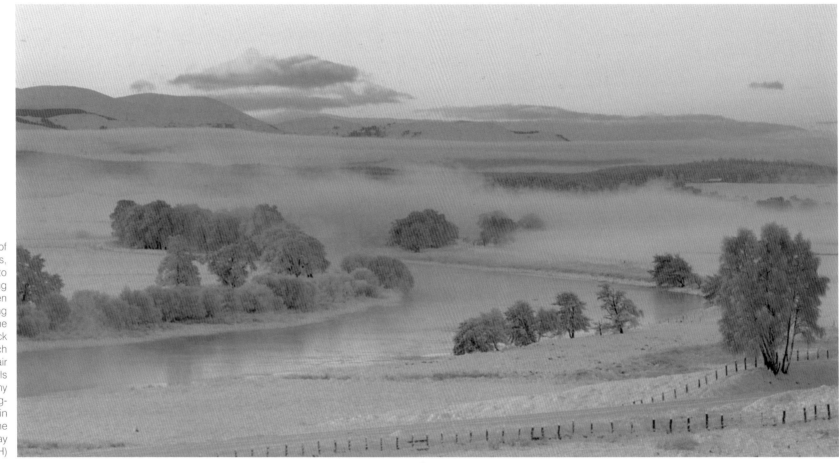

Following several days of sub-zero temperatures, the thermometer dipped to -19°C on this clear morning in January. Mist had frozen on the branches, coating the trees alongside the River Spey with a thick layer of hoar frost. With each intake of breath, the icy air condensed in my nostrils and frost was forming on my hat and gloves as I struggled to set up the tripod in the frigid conditions. The warmest it reached all day was -8°C. (MH)

In recent times, extreme fluctuations in winter temperatures have kept the rivers and lochs of the Cairngorms in a constant flux of freeze-thaw. Whether this is an indicator of longer term climate change remains to be seen, but for the time being, the iron grip of winter seems to be loosening. These etchings of nature on the bleak canvas of winter are landscapes in miniature; celebrations in texture and form. (PC & MH)

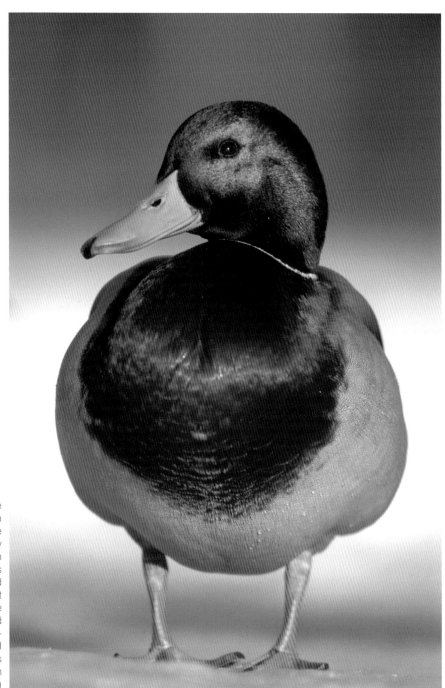

The mallard is one of those unfortunate birds which attracts indifference due to its familiarity. As I lay prone on a frozen lochan one January morning, this handsome male strutted about, the reflected light from the ice illuminating the irridescent colours around his head. Bemused passers-by could not fathom why I would go to such extremes to photograph such an 'ordinary' bird. (PC)

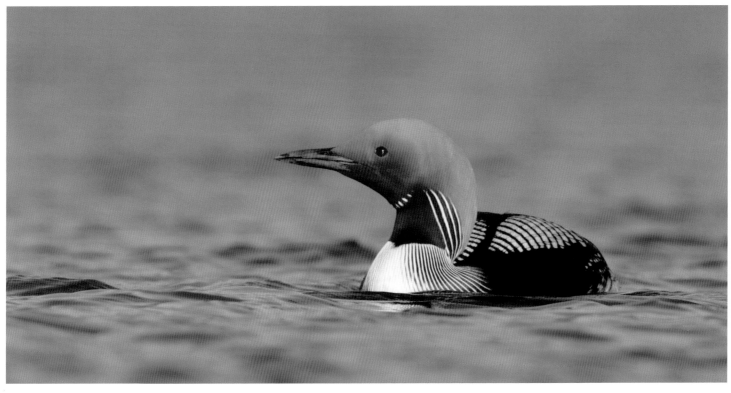

Although more common in the far north of Scotland, black-throated divers use the clear lochs of the Cairngorms to feed in summer. Like their red-throated cousin, their spring song is a series of mournful, desolate calls, sonorous and far-reaching. On their breeding lochs, their simple nest is susceptible to flooding and in an effort to alleviate this, some landowners provide artificial floating nest platforms. (MH)

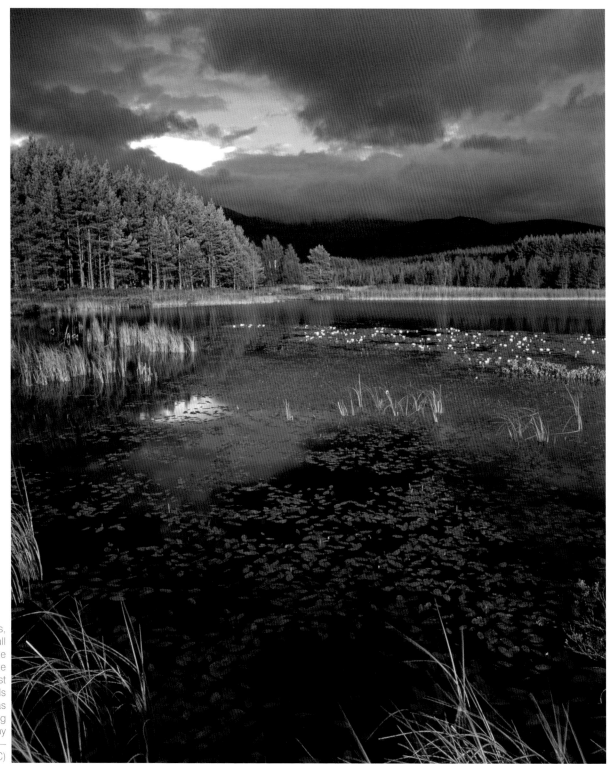

High over the distant hills, the storm clouds are full and threatening, turning the sky a deep, inky blue. The penetrating light that burst through the scudding clouds this August evening was exquisite. Even the thronging midges failed to deter my quest to capture the scene—for a while at least. (PC)

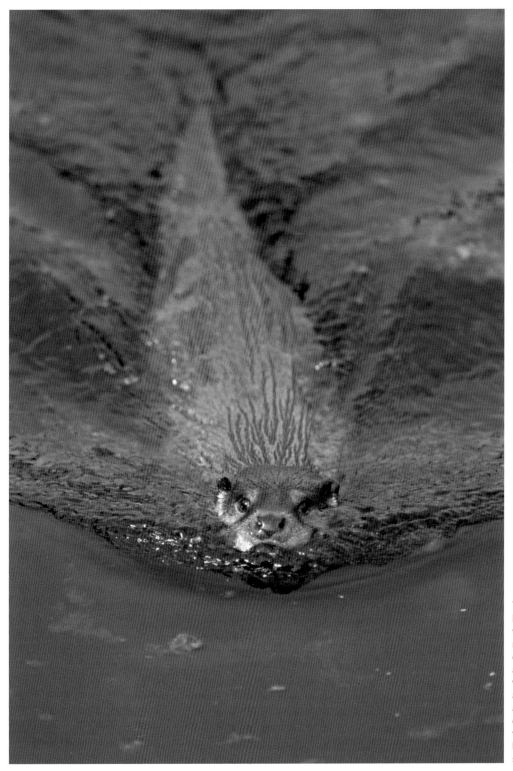

The clean burns, rivers and lochs of the Cairngorms provide otters with a welcome refuge and a plentiful source of food. They hunt primarily at night, preying upon a wide range of fish as well as amphibians and eels. They are most easily spotted in calm weather, when they are visible as 'swimming logs', breaking the otherwise flat surface of the water. (MH)

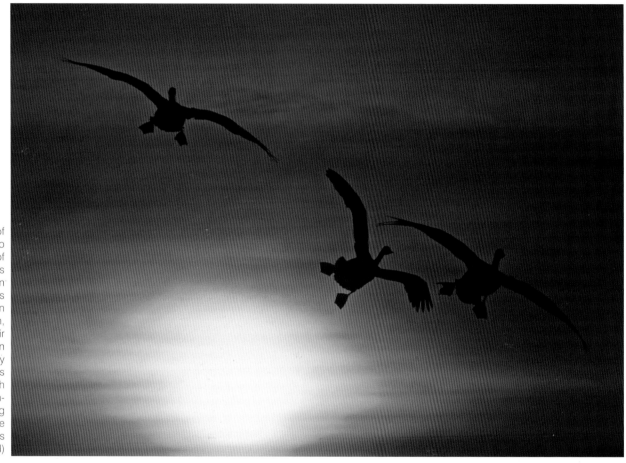

The evocative calls of whooper swans flying into their roost site are one of the highlights of a winter's afternoon birdwatching on Insh Marshes. The swans spend their day feeding on the rich aquatic vegetation, upending and using their long necks to reach down to graze. Occasionally, they take short flights across this vast flooded mire in search of new areas to feed, returning to their favoured roosting sites at dusk where they are safe from predators such as red fox. (MH)

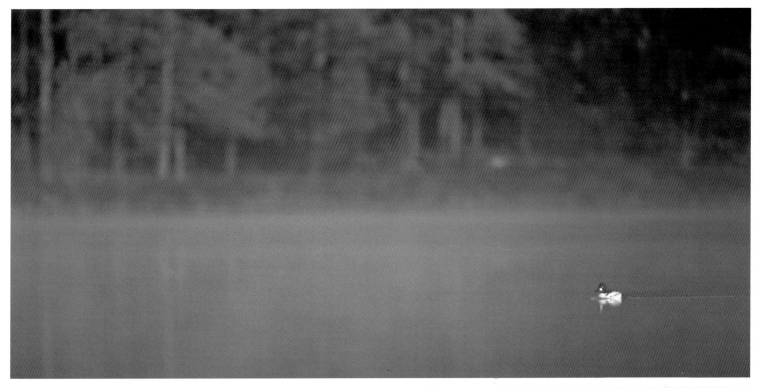

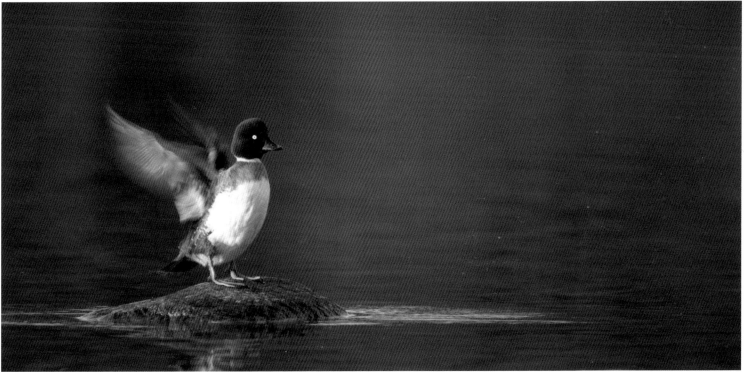

A calm spring morning is interrupted by the evocative calls of a male goldeneye as he winds up for his elaborate courtship display. Appearing out of the mist, he explodes into action—head held back and splashing the water with his feet, ripples radiating to every corner of the lochan. After an hour of frenzied activity, the water falls still once again, the male gliding serenely through the glass-like lochan, while the female takes time out to preen on a partially submerged rock. (PC & MH)

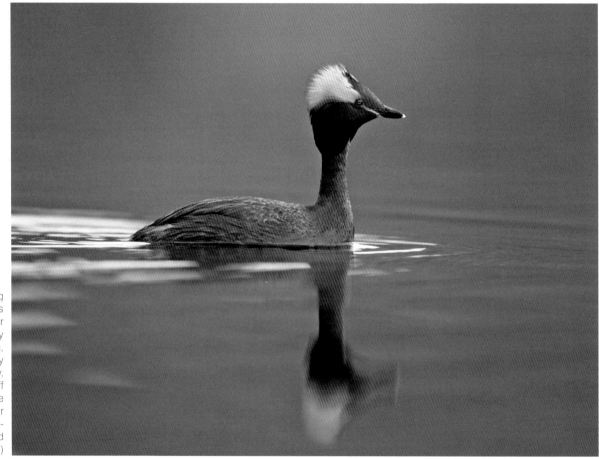

Bedecked in full breeding plumage, slavonian grebes seem to glow on the clear waters of a few Strathspey lochans. During spring, the pair engage in lengthy bouts of courtship activity, the male bird showing off his golden ear tufts to the female. At this time the pair also begin to investigate potential nest sites in secluded reed-fringed bays. (MH)

The unmistakeable silhouette of a mute swan, spectral in form, serenely emerges from a seemingly impenetrable mist on a numbingly cold winter's morning. (PC)

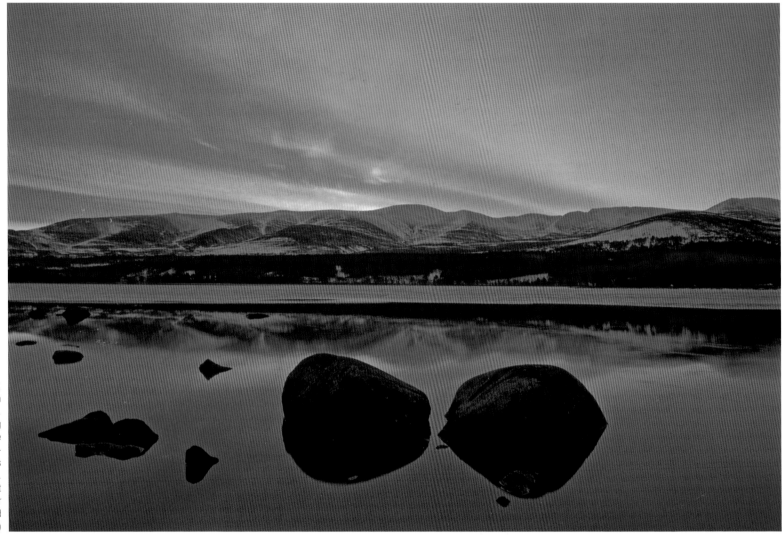

In anticipation of a clear, calm morning, my alarm went off well before dawn. Within half an hour of leaving home I was standing on the edge of Loch Morlich, working feverishly to record this magnificent winter sunrise. I had been to this viewpoint many times, but never before had the sky provided such vivid colour. (MH)

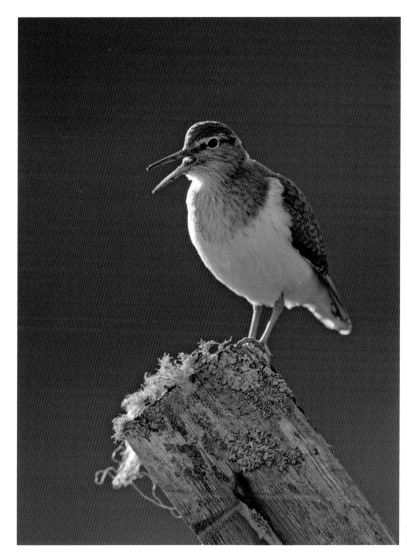

A summer visitor to Scotland, common sandpipers are found on the majority of our rivers and lochs. Their frantic courtship involves excited calling, wing fluttering and spectacular chases across the water. On this occasion, the male bird flew from the lochside onto a roadside fence post, from where he called repeatedly to the female. (MH)

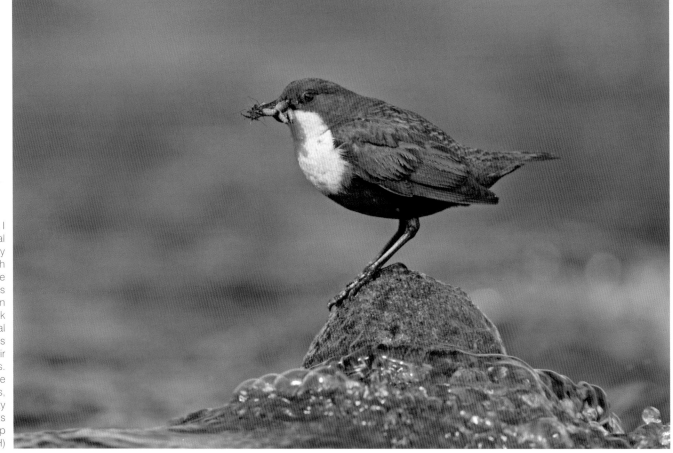

Throughout the winter, I was able to watch a local pair of dippers as they searched for larvae beneath the rushing waters of the River Dulnain. As early as January, the male often sang from a favoured rock in mid-stream and several times I witnessed skirmishes between the resident pair and potential incomers. By late May the pair were feeding well-grown chicks, allowing me an opportunity to photograph the adults from a makeshift hide set up under the river bank. (MH)

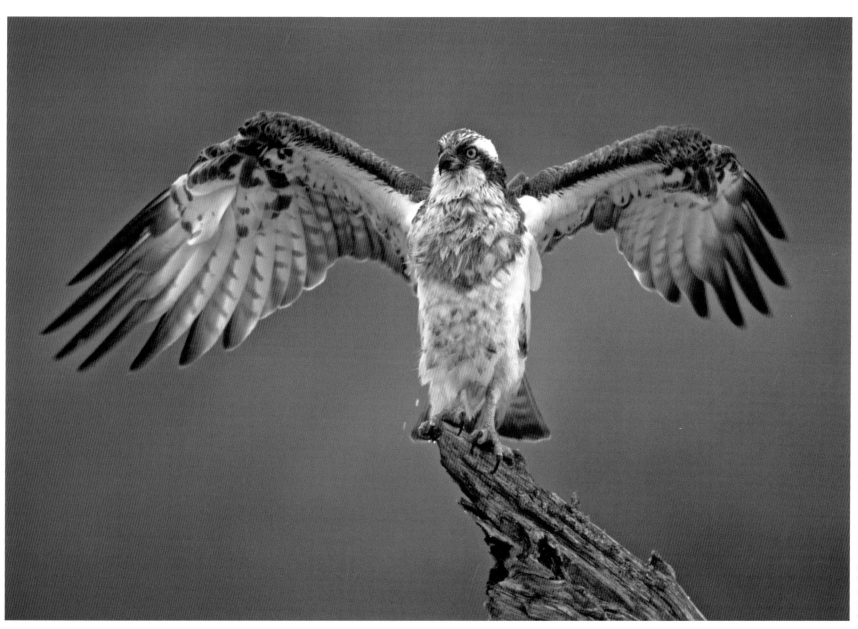

There can be no other wildlife species in the Cairngorms so symbolic of our growing appreciation of the natural world than the osprey. This male regularly used this fallen tree as a roost perch, where he would spend long periods preening. From the confines of my hide, I watched as he frivolously bathed in the river before returning to the perch to dry. Having played his part in rearing two young ospreys, he faced a long journey south to West Africa for the winter. Although fraught with danger, both he and his mate returned the following year to breed again. (PC)

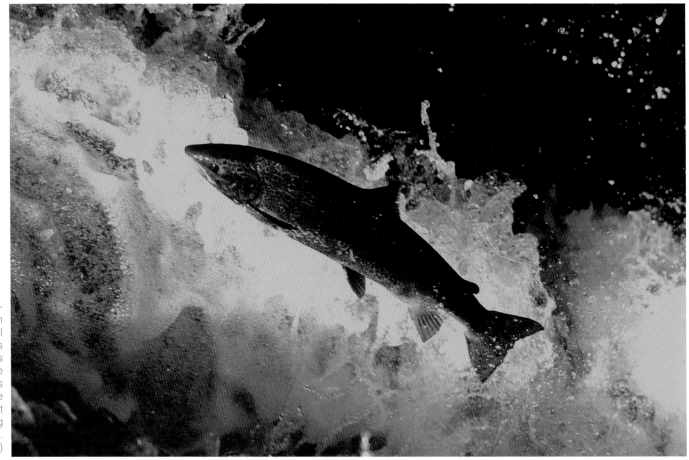

The survival instinct of Atlantic salmon is strong enough for it to withstand physical demands far beyond its apparent capabilities. This leaping salmon will have travelled a thousand miles or more to return to its place of birth, swimming against a raging current, resting periodically in quieter pools. (Laurie Campbell)

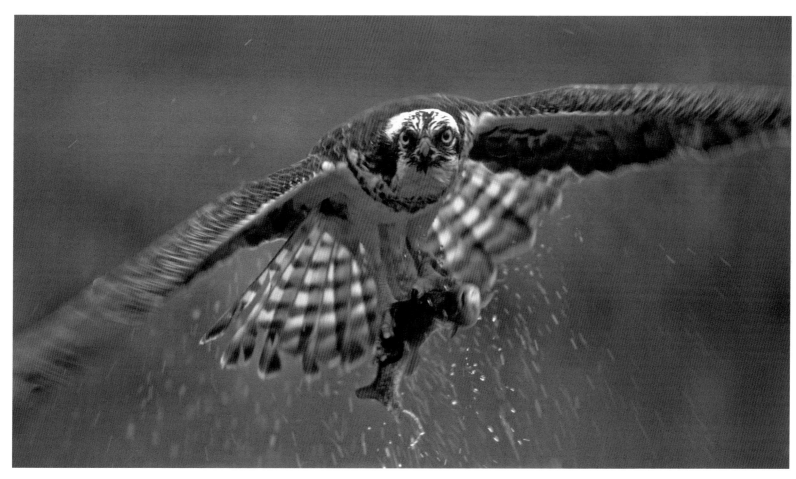

The sight of an osprey plunging into a Highland loch, is not one easily forgotten. For the osprey however, their search for food is not without risk: the fish must be grabbed with outstretched talons and manoevred into position—head first, torpedo-like—before take-off. If the osprey has misjudged the size of the fish, it can release it, but there are records of ospreys drowning by getting their claws stuck in the bones of a fish too heavy to lift. This osprey encountered no such difficulties. (PC)

PASTURES NEW

Man did not weave the web of life; he is
merely a strand in it.

Whatever he does to the web, he does to
himself.

[Chief Seattle]

The gentle rumbling of a distant tractor breaks the otherwise rural tranquillity. In its wake, a flock of black-headed gulls wheel over the exposed earth, dropping down to feast on earthworms and beetles. Other opportunists are keen to cash in on this short-lived spring bounty. Rooks are in abundance, calling noisily as they scour the furrows for signs of life, their dark glossy plumage iridescent in the soft evening sunshine. Jackdaws and starlings feed alongside, while dotted around the field, newly arrived oystercatchers and lapwings probe the fresh earth.

From a nearby fence post, a common buzzard takes a more considered approach. They too welcome the chance for an easy meal after a lean winter. Earthworms make up a sizeable proportion of a buzzard's diet early in the year and are especially important for inexperienced birds. Periodically, the buzzard drops effortlessly from its perch to seize a worm, systematically moving along the fence line from post to post.

By the time the farmer's work is finished, most of the exposed insects have either been eaten or have retreated to safety beneath the surface. Soon, barley will be sown, providing further sustenance for rooks, yellowhammers and other farmland birds that have adapted to this man-made environment.

For centuries, man has been shaping the landscape to provide food, fuel and shelter. Today, farming is an integral part of the Cairngorms countryside. Cattle and sheep rearing is widespread, while the most fertile areas in the glens are used for small-scale production of silage, hay, turnips and barley. Compared with the barren cereal prairies of southern and eastern Britain, farming in the Cairngorms National Park is of low intensity, providing refuge for wildlife and maintaining corridors to other important habitats.

While we perceive the forests and mountains as wilderness refuges, we dismiss habitats, often equally rich in wildlife, that have become so much part of modern-day life. Although extensive areas continue to be subjected to heavy grazing by large numbers of sheep, much of the agricultural lowland within the National Park is of high ecological value, most especially where traditional farming methods are employed. Changes to large-scale agriculture elsewhere have undoubtedly diminished its wildlife diversity, but in this corner of northern Scotland, the contribution that farmland makes to species diversity is without question. Purists might argue that the landscape is unnatural —of course this is true, but this need not automatically lead to ecological impoverishment.

For some species, such as grey partridge and yellowhammer, farmland is vital. For many other bird species, it provides a reliable source of food as well as nesting sites. Skylarks breed in the indentations made by cattle, their chicks flourishing on the myriad of insects that thrive on the unimproved grazing pastures. In summer, swallows, house martins and swifts hawk the skies for flying insects, utilising our farms and buildings in which to raise their broods. Scotch argus, small pearl-bordered fritillary and common blue are amongst the butterfly species which feed on unimproved, species-rich grassland, ablaze with floral colour in late summer.

Farmland also provides habitat for other species that favour open ground. Lapwings and curlew nest in hay meadows, grazing pastures and fields of young crops. Over the past decade or so, these have been joined by cosmopolitan oystercatchers, a species increasing on farmland. Kestrels favour rough grassy margins, where mice and field voles are in abundance. Brown hares frequent open ground for much of the year, nibbling on the newly emerging growth in spring, a time when they can be seen engaging in bouts of boxing. Contrary to earlier theories of males fighting, it is now accepted that boxing takes place between the doe and an over zealous buck, the female resisting the advances of her amorous suitor.

National and European policies, along with technological advances in the name of progress, keep the British agricultural industry in constant change. In the past, local farms would have played host to corn buntings and twite now both scarce in the area. Red and black grouse benefited from the traditional practices of cutting, stooking and threshing, which also provided a plentiful supply of seed for other birds and mammals. Prior to improved drainage, wet grazing land was commonplace and formed an ideal habitat for breeding waders, while the old hay meadows were the haunt of corncrakes, a species that is now chiefly restricted to the Western Isles.

The past fifty years has seen unprecedented changes in farming with EU subsidised 'improvements' resulting in a huge decline of farmland wildlife across Britain. In partial contrast, the changes that have taken place within the farming communities of the Cairngorms have been less damaging. This is due in part to a more enlightened view taken by many farmers who regard environmental conservation as a high priority of land management.

To alleviate part of the financial sacrifice faced by farmers who hold the conservation ethic in high regard, the Cairngorms is designated an Environmentally Sensitive Area (ESA). Two of the aims of this designation are to support existing farming practices which have maintained wildlife habitats and to encourage measures that will enhance the environment. ESA designation pays farmers for environmentally friendly land management such as reducing stock numbers to facilitate natural woodland regeneration. Cattle in low numbers can assist in this by trampling the ground and exposing fresh earth. Sheep, however, have been widely implicated in the lack of natural forest regeneration on the higher ground. The ESA scheme has recently been replaced by the Rural Stewardship Scheme.

Other initiatives, which promote less intensive farming and habitat re-establishment, have been introduced by organisations such as Scottish Natural Heritage. One such scheme, assisted by the local Farming and Wildlife Advisory Group (FWAG), is the Cairngorms Upland Grain Initiative. Following a pilot in 2000, this scheme has encouraged farmers and crofters to grow small areas of 'sacrificial' spring crops in fields adjacent to woodland. This would have been commonplace in the past but changes in regime mean that most small-scale cereal fields on the higher ground are now sown for summer silage. Of the 41 species of birds recorded using these experimental sites, 85% are classified as rare, declining or protected, including seven priority species: skylark, song thrush, linnet, grey partridge, reed bunting, capercaillie and black grouse.

The presence of capercaillie and black grouse at these sites is of particular interest. Prior to the 1970s these threatened game birds were regular visitors to oat fields where they fed under the stooks in winter. With the loss of this habitat, the birds lost a valuable winter food source, a factor that may have contributed to their rapid decline over the past 30 years. Projects such as the Upland Grain Initiative emphasise the importance of farmland not only to species such as partridge and yellowhammer, but also to a host of 'fringe' species which historically took advantage of a wider range of habitats that are no longer available.

Ultimately, the contribution that Cairngorm farmers and crofters make to the wildlife diversity of the area is only partially determined on a local level. EU policy will influence, if not dictate, the future for local agriculture. Presently, it would appear that policy reform will further encourage wildlife-friendly farming and initiatives such as farmers markets and tourism diversification will allow for profit without wringing the land dry. (MH)

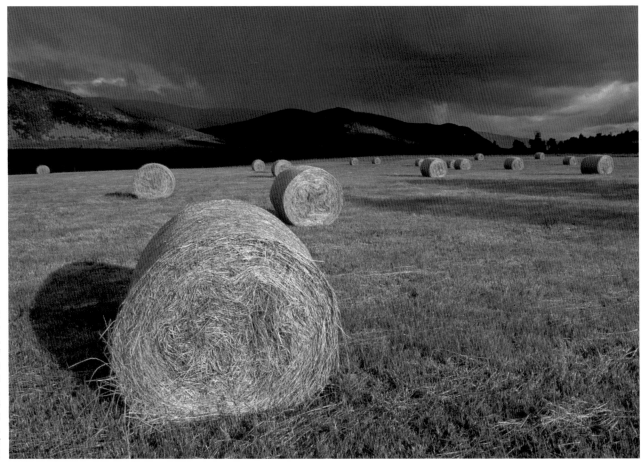

The timing of the hay cut in this part of the world is anything but an exact science. The weather in late summer is almost impossible to predict and frequent rain showers are not uncommon. The dynamic lighting on this recently cut field results from a storm raging over the hills, thankfully skirting the lower ground. (PC)

As much an icon of the Highlands as an eagle or a red deer, this much photographed breed of cattle is well suited to the inhospitable conditions that are found in the Scottish Highlands. Capable of surviving where other breeds would perish, Highland cows are also highly resistant to disease and able to prosper on relatively poor vegetation. Despite their appearance, they are generally docile animals, but should nevertheless be treated with respect. (PC)

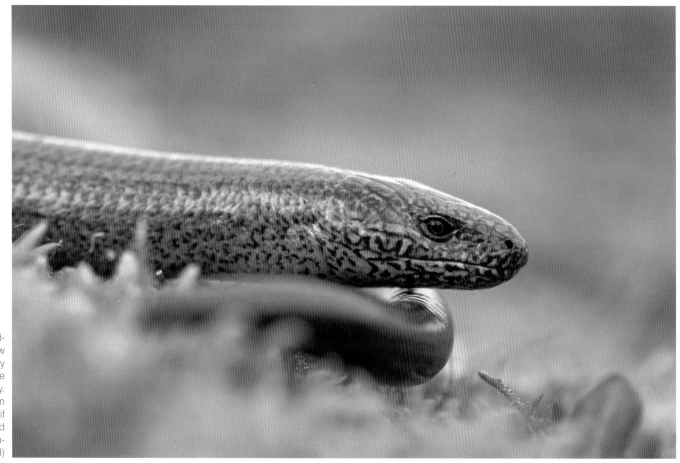

In common with all cold-blooded creatures, slow worms seek out warm, sunny places in order to energise their bodies into activity. Where they occur they can form substantial colonies if conditions are suitable and there is a ready supply of insects on which to feed. (MH)

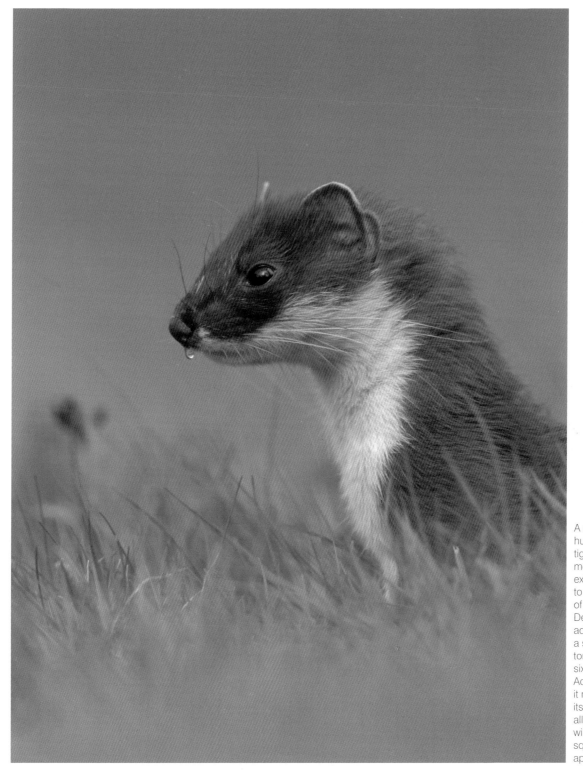

A cunning ploy used by a hunting stoat is to run in tight circles around its prey, mesmerising it to such an extent that the stoat is able to lock its jaws onto the neck of its traumatised victim. Despite its small size (an adult male is 30cm in length) a stoat is a ferocious predator, capable of killing a rabbit six times heavier than itself. Active both day and night, it relentlessly tracks down its prey by scent. Occasionally the rabbit being hunted will become panic-stricken, squealing loudly as the stoat approaches. (MH)

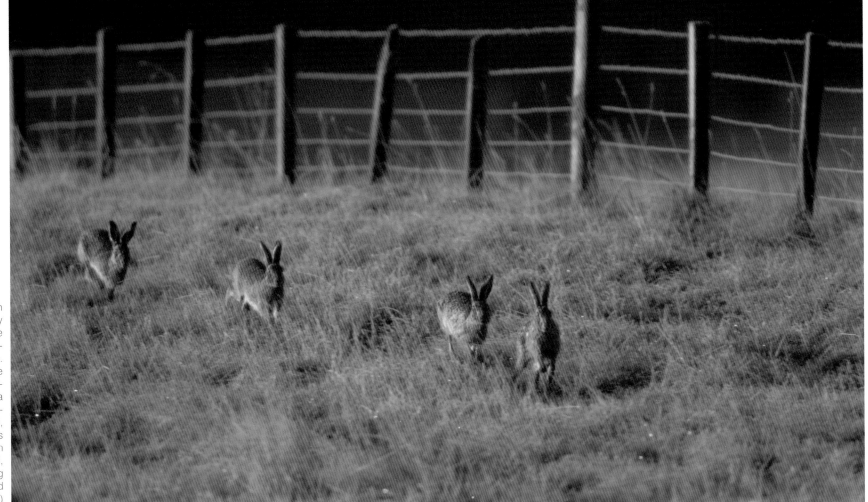

Brown hares are common in the farmland around my home, but although I see them regularly I have precious few images on file. Moments before this chance encounter I had been attempting to photograph a roe buck. The deer regrettably got wind of me and fled, but as I stood up, two hares ran into the field about 100m away. Two more followed, the four animals chasing each other around the field in a blur of motion. (MH)

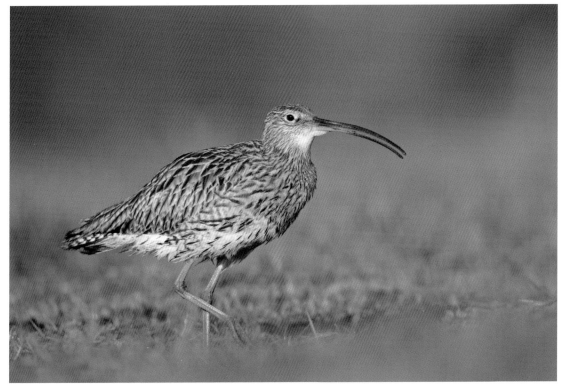

After several mornings spent prostrate under the cover of my hide, waiting motionless in the hope of photographing brown hares, I got lucky when a pair of curlews dropped in literally only a few metres away. Completely unaware of my presence one individual began to preen so close that I was unable to get the whole bird in the frame. (MH)

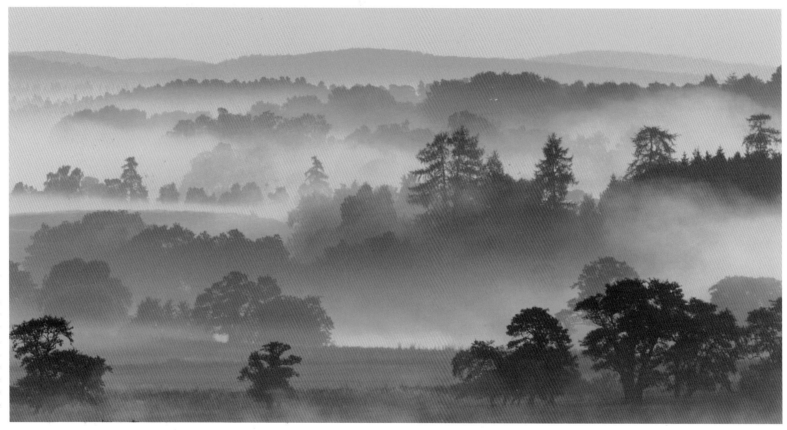

A scene overlooked under ordinary conditions can be transformed into one of extraordinary beauty by the fusion of light, weather and season. Timing was paramount for the success of this image, for only in the height of summer does the sun rise far enough to the northeast to backlight the morning mist. (MH)

In summer a succession of wildflowers decorate wayside verges, meadows and lightly grazed fields. The colourful heads of melancholy thistle are among a number of purple flowers, which also includes knapweed and spear thistle. Later in the summer, the delicate nodding blue flowers of harebells line the roadsides and may continue to bloom well into September. (MH)

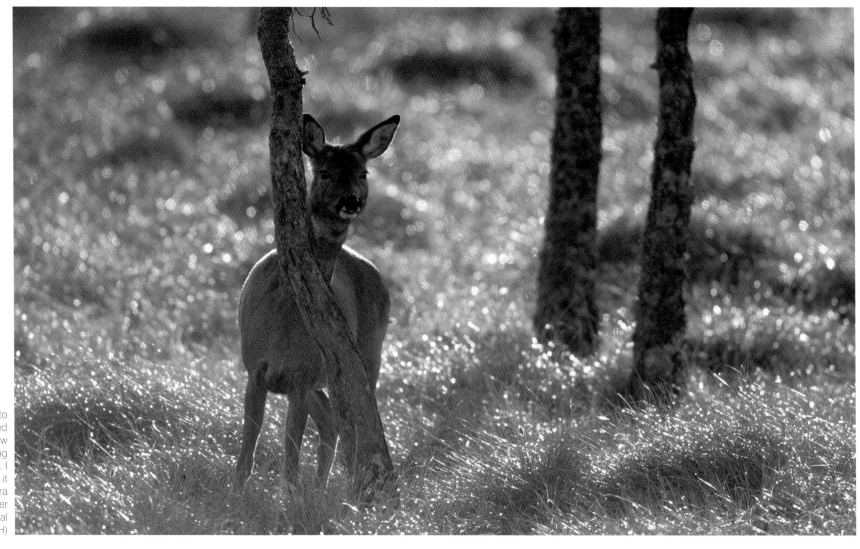

A chance encounter close to home. This roe doe stared intently at my car for a few seconds before retreating to the cover of the forest. I learnt some time ago that it is wise to have the camera set up and ready whenever I am out driving the local lanes early in the day. (MH)

Following centuries of persecution, red foxes have learnt to keep a low profile. Unlike in other parts of Britain, foxes throughout much of the Highlands tend to be chiefly nocturnal, rarely venturing abroad in daylight. In winter, their demonic calls and barks, which signify the oncoming mating season, alerts us to their presence, but otherwise they remain largely unseen. Young cubs, which appear outside their earths in June, are a little less nervous than the adults, which allowed me an opportunity to photograph this individual soon after daybreak. (MH)

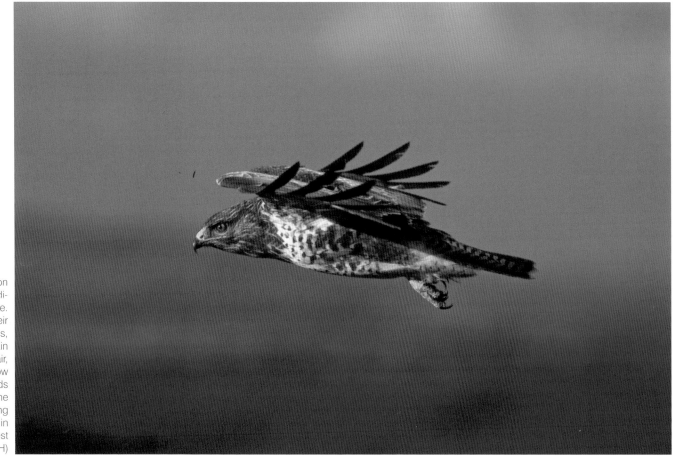

On windy days, common buzzards use the conditions to their advantage. Facing into the breeze, their wings angled backwards, they are able to remain almost motionless in the air, searching the ground below for potential prey. Buzzards are a common sight in the Cairngorms, often perching on fence posts, where in summer, the annual harvest disturbs small rodents. (MH)

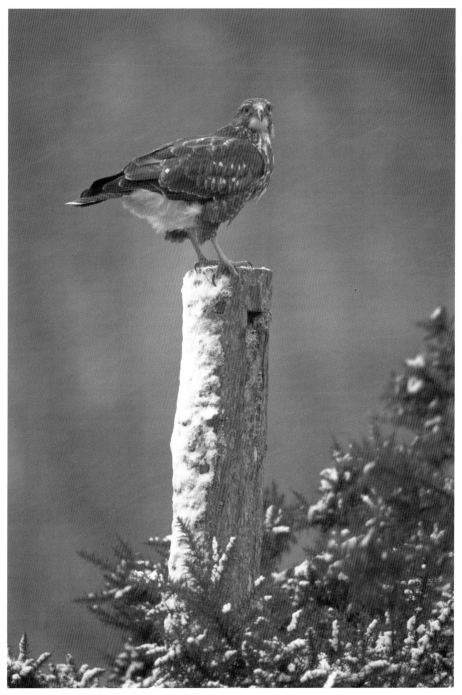

The evocative mewing of overhead buzzards can be heard almost anywhere in the Cairngorms. They have expanded both their population and range in recent years and along with the kestrel, are now Britain's most common bird of prey. This female was born in woodland close to my home and was attracted by roadkill rabbits I left out in winter. She was, however, very wary of my hide and I had to dig it well into the ground to make it less conspicuous. Early one winter morning, she alighted on this post momentarily before flying down onto the bait. (PC)

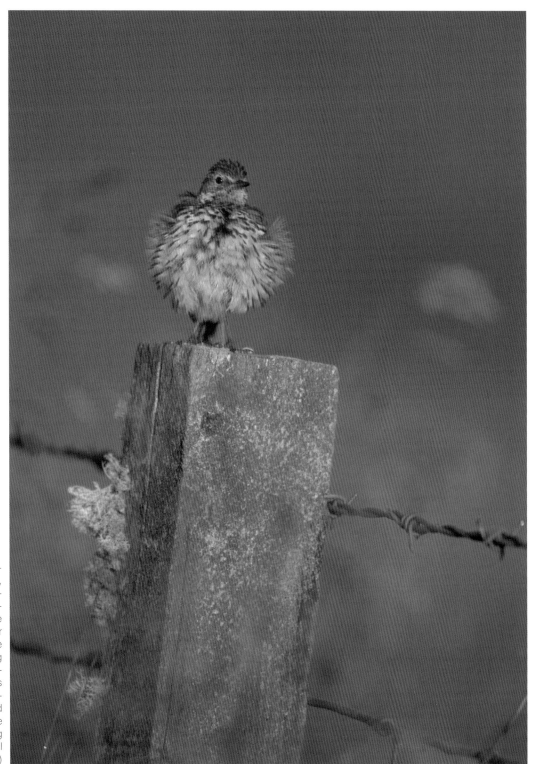

An unassuming bird, meadow pipits are widespread, adapting to a range of habitats. After the breeding season, many choose to leave the moors and head to lower ground where food is more plentiful. Early each morning they spend their time preening, gathering along fences in large numbers. This individual was photographed from the car window in the first light of the day, fluffing out its feathers after a spell of preening. (MH)

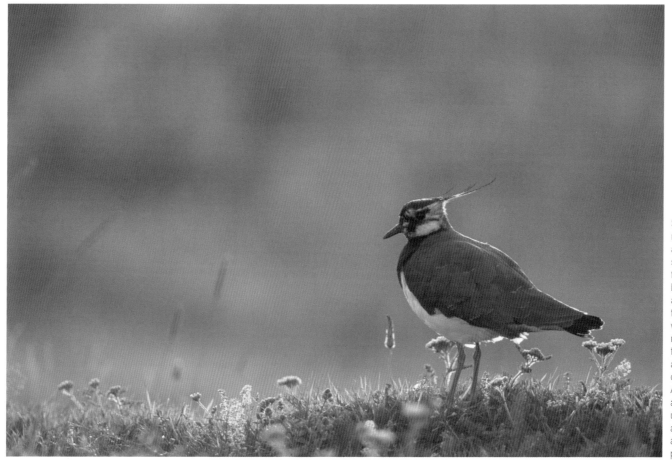

Strathspey is one of the most important areas in Britain for breeding waders, and supports a healthy population of lapwings. They arrive back on territory in March and spend the spring raising their broods in the fields and wet meadows throughout the region. One summer, I was fortunate to stumble across a pair of lapwings and their chicks in a local meadow. At first they were wary of the approaching vehicle which I used as a mobile hide. After a few days, they became almost oblivious to my presence. (MH)

LOOKING FORWARD TO THE PAST?

Man is faced with a choice between two values: material worth
and spiritual worth. Material worth is fickle, transient, unenduring; it is
also discriminatory, offering privilege to the few while keeping
opportunity from the many.

Matters of the spirit are known to every
single human being, the very pivot of the
heart.

[V S Pritchett]

The latter part of the 20th century and the dawning of the new millennium have brought unprecedented change to life on earth. Unrelenting, the pressures facing our wild places and the intricate ecosystems that depend upon them, have never been greater. Burgeoning financial wealth has fuelled our perceived need for material acquisition. The resources needed to satiate this hunger and the resultant waste, impact upon our environment, even in the wildest of places. We are taking more from nature than it can ultimately give.

Hand in hand with such a trend, is our increasing alienation from the natural world. We have become detached from, rather than part of, living nature. Yet ironically, there has never been more interest and concern about the natural world. Powerful media imagery draws people in increasing numbers to Britain's remaining wild places and public wildlife agencies and conservation bodies have never been so well supported. Flagship species such as the osprey and capercaillie have become wildlife icons —media celebrities.

The pockets of wild land that remain, influenced by human intervention but not entirely tamed, are our spiritual refuges, places where we can re-connect with who we are. The Cairngorms has long since been one such place. It is ironic that John Muir, a native Scot, was so instrumental in establishing the concept of national parks across North America, yet never saw them in his homeland. He would, no doubt, have allowed himself a self-congratulatory smile when his great grand-daughter Liz Hanna opened the Cairngorms National Park—Britain's largest—in September 2003.

The difficult task of reconciling an already eclectic mix of land use interests within the park lies ahead. There is a legislative obligation on the newly-established Park Authority to deliver on the objectives set out for Scotland's National Parks. In a nutshell, this means protecting the integrity of our natural heritage whilst promoting sustainable economic development. Most would agree this is not easy. Some might argue that the two aims are diametrically opposed.

Are we really willing to compromise continued economic growth to preserve or indeed enhance wild places such as the Cairngorms? Can we carry on as we are and give long term protection to our wildlife? Should, in fact, the presence of a locally rare bird prevent the building of a luxury holiday home? Should we seriously consider re-introducing keystone species of wildlife that would bring inevitable conflict within rural communities? Ultimately, is this land and its wildlife ours to control? Do we really understand nature's business better than it understands itself?

Many believe the Cairngorms National Park was created for people. It provides a slice of the wild for 'nerve shaken urbanites' (John Muir). Its wildlife is there for 'people to enjoy' and we are reminded of the need to conserve so that 'future generations' can enjoy this place. But should we regard our birds, mammals, insects and flowers simply as another resource to encourage visitors and allow those living in the park to profit? Is this the only reason we should protect golden eagles, pine martens and red squirrels?

There is increasing support for the concept of ecological restoration—in many ways the antithesis of conservation, as it prescribes the recreation of wild, self-sustaining ecosystems controlled only by natural forces. It flies in the face of 'management' and by definition does not seek simply to retain what we already have, rather to replace what we have destroyed.

Article 22 of the EC Species and Habitats Directive 1992 requires member states to examine the feasibility of reintroducing extinct native species that once occupied an important ecological niche. The European beaver has been on the brink of being returned to Scotland for some time and Insh Marshes was highlighted as a possible release site. At the time of writing however, the Scottish Executive continues to procrastinate. The anti-beaver lobby cites several biologically inaccurate claims, yet its vociferous protests act as a barometer for the likely reaction to more ambitious re-introductions.

Wildlife management has entered the realms of mainstream politics. As we embark on what many hope is a new era in the way the Cairngorms is perceived and utilised, questions about the future of the creatures that share our space remain unanswered. Albert Einstein said: 'We cannot solve the problems we have created with the same thinking that created them'. New thinking however, must embrace not only idealism but ecology, science, culture and economics. The confusion of short term change may be uncomfortable, but if we have the patience to look beyond the immediate future and the humility to realise that some things should remain beyond our control, then we may act wisely.

Generations beyond our own will testify to our willingness to accommodate other species in our lives, accepting that their presence will often impinge upon us and that they cannot be controlled without consequence. The legal framework presented by the designation of the Cairngorms National Park provides a foundation for a fresh approach. It is an opportunity to reinvest in the natural world rather than continually exploit it. An opportunity for this place to remain a Wild Land.(PC)

Increasing recreational pressure in wild places the world over, leaves those responsible for prescribing management policy with tough decisions. Knowledge of, and appreciation for, the wild qualities of The Cairngorms is nurtured by visitors' first hand experiences. Conversely, some wildlife species—already facing decline —are sensitive to sustained disturbance. (MH)

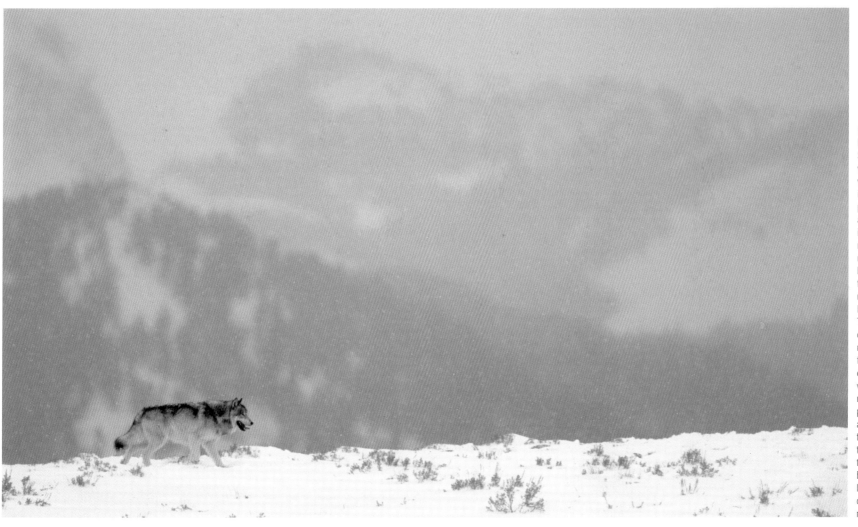

By the 18th century, wolves had finally been silenced in Scotland. In 1995, amidst worldwide media attention, wolves were reintroduced into the world's first national park—Yellowstone. After an absence of sixty years, opinion on the wisdom of such a move was polarised. Visitor numbers to the park rose by 60% in the first year and ten years on, wild wolves now roam much of Montana, Idaho and Wyoming. There has been much discussion over whether a wolf re-introduction would be feasible in Scotland. Many claim it is our duty to restore what we have destroyed and reinstate natural predator-prey relationships. Others argue that livestock predation and the perceived threat to human safety would be too high a price to pay. Despite extensive research literature on the species, opinion for and against is most often ill-informed. (MH)

Re-establishing large areas of native woodland has become a conservation priority in recent years. The forests of the future look set to more closely mirror the forests of the past, with a mixed range of native species being planted and natural regeneration being encouraged wherever possible. Views are divided on the best approach to forest expansion, some favouring traditional management methods such as deer fencing, others lobbying for a more natural re-wilding process. (PC)

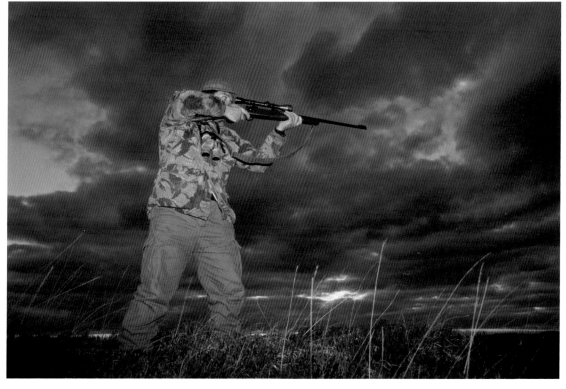

Deer stalking remains a major land-management activity across the Cairngorms. Many estates which derive a significant income from stalking are resisting calls for increased culling to facilitate woodland recovery. The value of stalking estates has traditionally been measured by the number of deer on the land, hence an entrenched reluctance to reduce numbers and cease winter feeding. Deer management remains a complex issue. (PC)

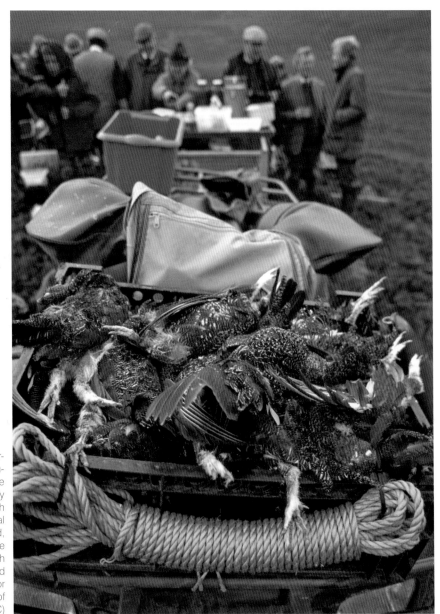

Traditional sustainable harvesting which safeguards rural livelihoods, or exploitative blood sport of the financially privileged? With so much of the Cairngorms National Park consisting of moorland, much of it devoted to grouse shooting, the way in which these moors are perceived and managed is critical for the future of a wide range of species—including us. (PC)

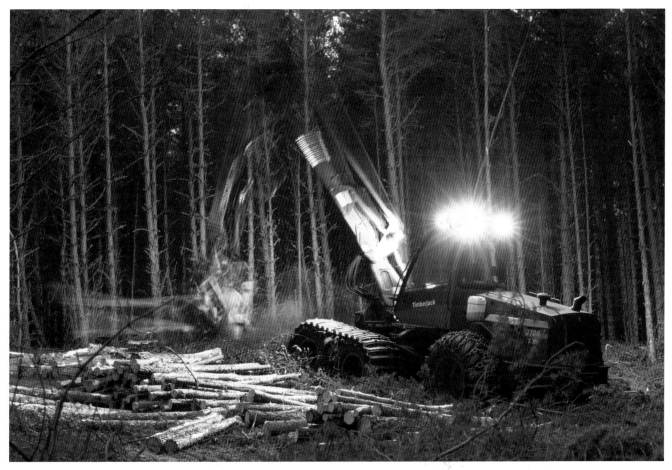

Large areas of the Cairn-
gorms are planted with
uniform rows of fast-growing
conifers, many of origins
outwith these shores. A
legacy from the post-war
requirement for more
home-grown timber, these
plantations have now largely
matured and harvesting
methods are efficient but
historically unsympathetic. In
an effort to improve species
diversity in these planted
forests, the uniformity of the
stand needs to be broken.
This often results in short
term scarring of the land
and displacement of wildlife,
but over time will ensure a
more enriched forest. (PC)

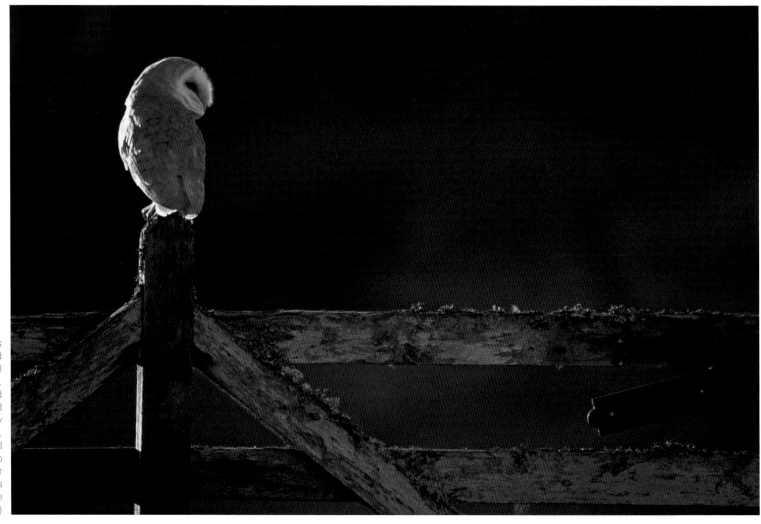

If our climate continues to warm, the long, cold Highland winters may well become less frequent. Some wildlife species could find it difficult to adapt and local extinctions are likely to occur. There are others, such as the barn owl and kingfisher, that will be able to take advantage of a milder climate and may become a more common sight in the park. (MH)

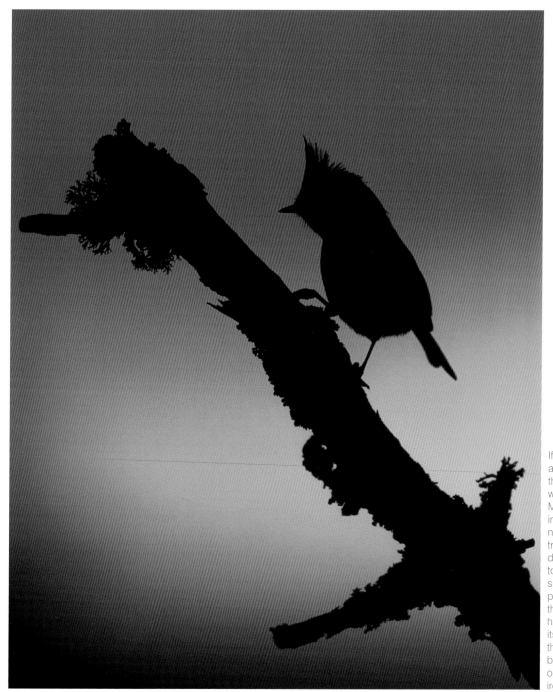

If this crested tit, unmistake-
able in profile, can withstand
the vagaries of a harsh
winter in the pine forest,
March will see it excavat-
ing—woodpecker like—a
nest hole in a decaying pine
trunk. Ancient pine forest,
despite increasing efforts
to expand its range, is itself
susceptible to rising tem-
peratures. At a point when
the forests' ecological value
has finally been recognised,
its demise and potentially
that of the crested tit, could
be fuelled by forces beyond
our immediate control: an
irony indeed. (PC)

It is widely accepted that the number of grazing animals in much of the Cairngorms is too high to allow natural regeneration of woodland. Deer fencing is seen as an effective tool in zoning different land uses, but it is also visually intrusive and has been implicated in the decline of forest grouse. In other areas, where sheep have been removed and deer reduced to a more natural level, the forest is returning naturally without the need for man-made barriers. (PC)

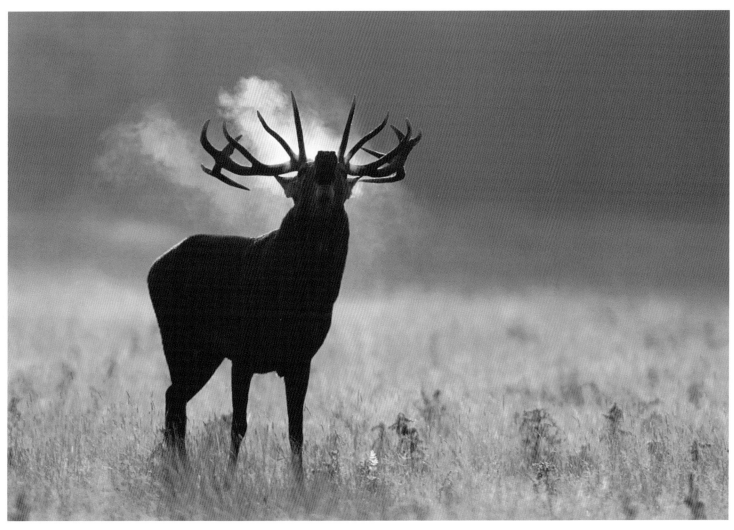

Almost every wildlife species has experienced the dubious benefit of our management skills at some point. In the past, we have manipulated other species to our own ends, without the knowledge to foresee the consequences. Presently, red deer are at the epicentre of land management debate; tomorrow it is likely to be the beaver or eagle. Perhaps the future will herald a more charitable outlook towards our fellow species. (MH)

The European beaver became extinct in Britain in the 16th century. After 157 re-introductions elsewhere in Europe, Britain remains only one of a small group of countries which has not yet re-introduced the beaver to its former range—a statistic that is likely to become an embarrassing reflection of our conservation credentials. The beaver is a land architect and its ability to alter landscapes—often quite dramatically—has undoubtedly hindered its return. The Scottish Executive cites the need for more research as the reason for the delay. (Niall Benvie)

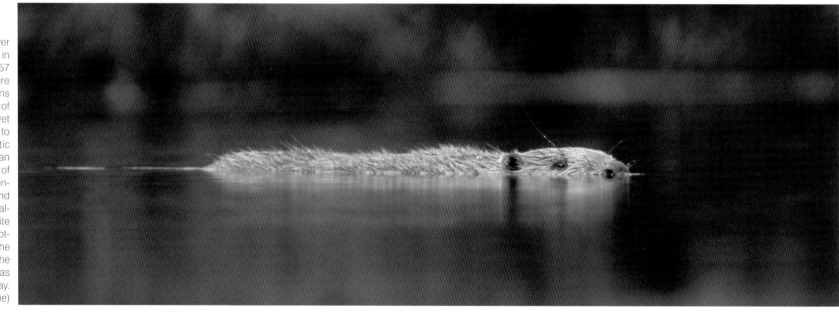

Our predecessors have handed to us a certain degree of land impoverishment, albeit not necessarily intended. We now have the knowledge—and for the first time, the capacity—to avoid further degrading this special place. Will this young boy thank or condemn us when he has children of his own? Will he be able to show them lekking capercaillie deep in an ancient wood; the aerial acrobatics of red kites soaring in clear skies or the intricate work of beavers in forest lochans? Will he and future generations know this place as a truly Wild Land? (PC)

IN MY VIEW

To gain an insight into how the wildlife and wild places of the Cairngorms is perceived, we asked several people who live and work in the area, to provide a vision of how this place may look fifty, a hundred years from now. We asked for a personal view and not one necessarily that reflects the policies of their employers. Here is what they said...

Jim Gillies is the Recreation Manager for Forestry Commission Scotland's sites at Glenmore and Inshriach. Jim has vast experience in land use issues, previously working as a head stalker and countryside ranger. He lives in the Cairngorms National Park with his wife Helen and two sons.

Over the past few decades, it has become apparent that more and more people are using the hills, forests and lochs of Scotland. They seek peace, quiet, inner reflection or a chance to participate in outdoor pursuits. This increased visitation has the potential to lead to a 'killing of the golden goose'—destroying the very reason that brings people to this special part of Scotland.

We now have the Cairngorms National Park—a designation in its infancy but one that many people believe will draw more visitors and perhaps lead to over-capacity in certain 'honey pot' locations. In my view, the park is sufficiently extensive with a wide enough range of habitats to cope with present visitor numbers and not compromise their expectations.

A huge attraction of the park is the ability to study wildlife—from red deer on the hills to ospreys fishing crystal clear lochs; from butterflies and moths to fungal forays—this is an area rich in natural heritage. It is also an area largely in private ownership. Most estates are happy to accommodate visitors, indeed in many cases they must to ensure survival. The days of signs warning of 'high velocity rifles in use' or 'beware of the bull' are largely gone. Such intimidation is no longer acceptable. Visitors should be made to feel welcome.

So can nature survive this potential onslaught of people? Many 'conservation' agencies are already planning for the future. Glenmore Forest is in the process of being restructured. It has remnants of the ancient Caledonian pinewoods and we need to preserve this unique gene bank, not just of trees but the associated flora and fauna. This is a vision for the future that will take 100 years or more to achieve. Other more immediate initiatives include habitat improvement for butterflies—this can happen in just a few years.

Future visitors to the Cairngorms will reap the benefits. With new footpaths being established, people will be able to experience nature for themselves. There are increasing numbers of guided excursions and wildlife watching hides. By providing good information to both visitors and local people, the delicate balance between human activity and the natural world can, in my view, be sustained.

The one fly in the ointment is global warming. Habitats and the associated species will likely change. We may lose ptarmigan and snow buntings from the high tops. We may also 'win' species, such as the exotic looking hoopoe or butterflies and plants from the Mediterranean.

By heeding advice, we can still maintain a huge variety of interesting species attracting people from all over the world. We sometimes underplay wildlife-watching in Scotland compared to the gorillas of Rwanda or the whales off the coast of South Africa, but as regular visitors to Scotland will testify, it's not just the variety of wildlife here but the country itself and the people that make it so special.

Ian Rowlands is a partner in Speyside Wildlife, specialising in arranging wildlife watching holidays in the Cairngorms National Park and around the world. Having initially trained as a journalist, his experience includes working as an ecologist for the Dartmoor National Park and 5 years wardening for the RSPB. He has a strong interest in conservation, business, travel, and the role eco-tourism can play in sustaining rural communities.

We need more wildlife. Have you ever watched a soaring buzzard, grinned as young rabbits chase around a meadow or watched mesmerised as rain sweeps across mountains? If any of these strike a chord, then just imagine how good you'd feel if some truly 'big' wildlife and wilderness experiences were at hand—then you'd be experiencing 'biophilia' meaning 'life-loving'. Perhaps to you and me, it registers more readily as a feeling that we like wild places, that we need wildlife, that it makes us feel good.

In California's Yosemite National Park, towering granite buttresses, waterfalls, awe-inspiring redwoods and wild animals inspired John Muir, a Scot, who became the father of America's national parks system, to write: 'wildness is a necessity, a fountain of life' In Scotland we are at last following Muir's lead and demanding national parks to call our own.

Increasingly, people are beginning to say 'Hey, we've walked on enough concrete, been stuck enough in traffic jams, smelled enough air pollution... we want to get amongst wilderness, to smell the flowers and really experience some wild animals'. But let's be honest, we wouldn't recommend that they stay in this country to experience these things.

If national parks in Scotland are to be held up for comparison against the best in the world, then their quality of wilderness and wildlife will be found to be lacking. Scotland's so called 'big five' mammals are badger, pine marten, fox, otter and wildcat. All of them are difficult to see in the wild and all will fail to excite the level of enthusiasm and tourist revenue that other parks around the world benefit from.

We may not seek to emulate Africa's leopard, lion, rhino, buffalo and elephant, but what about countries closer to home, themselves awakening to the economic and spiritual potential of wildlife? What about Norway and Finland with their sea eagles, beavers, bears, wolverine and lynx—animals that all once lived in Scotland. Should we blank our minds to the possibility of bringing them back?

It's certain that visitors to the Cairngorms National Park will expect to see wildlife. Perhaps then, we should consider equally the opportunities, as well as the complications that re-introducing lost species might present. In addition, a national park needs wildlife, not just for visitors' sake, but also for the well-being of the local communities who should be entrusted to manage it. There are economic benefits for local people in enhancing Scotland's wildlife. There are social benefits too: not just in sustaining rural communities but also through a spiritual enrichment of all of our lives.

David Carstairs joined the Nature Conservancy Council (now Scottish Natural Heritage) in 1979. He has worked in a variety of locations across Scotland—St Cyrus, Glen Tanar, Shetland and now the Cairngorms. His present position as Area Officer for SNH in East Highland brings him into contact with many issues surrounding Scottish wildlife. He lives with his family in Carrbridge, north of Aviemore.

I've always been fascinated by the names of Scotland's National Nature Reserves (NNRs). There's a sense of adventure, of mystery, about them. Beinn Eighe, Hermaness, Creag Meagaidh, Silver Flowe. Places which tell of human history and wild nature. Here are remote hills and glens, hut circles and shielings, dark lochs, ancient forests and fingered coasts. Fashioned by nature, yet modified by man. Our natural heritage.

Beinn Eighe in Wester Ross was the first NNR to be declared, followed by the Cairngorms in 1954. This special place is an exceptionally wild area of high ground looming over the Strathspey village of Aviemore. The 'plateau' covers over 60 square miles of rock, ice and water blasted by arctic winds. There are great crags of red granite and sunless coires where snow lies for much of the year. Extensive forests of Scots pine flank much of the low ground, and as in all of Scotland's NNRs, nature comes first.

It is many years since naturalists first walked among the pine forests and into the high coires the home of golden eagles, dotterel and snow buntings. Capercaillie, pine marten and wildcat still skulk among the ancient pines, albeit in small numbers.

We, on the other hand, are on the ascendancy. The rise in car ownership has given us greater freedom to enjoy the countryside. Television has brought the outdoors to our firesides. We save whales and support rare birds. We do this in increasing numbers. We ski and walk, enjoy bike rides and horse riding. We climb, watch birds, canoe and fish. We are leaving a heavy footprint on our environment.

Do we see this as a problem? The National Nature Reserve series was built on science. Natural units—mountains, woods, coast and river—the building blocks of individual, nationally important places. So important were they that many NNRs could only be visited by permit. That wonderful series of landscapes, with their enigmatic names and mysterious wildlife, were boxed away. Most of us hadn't heard of them, let alone been to one.

Things have changed. We have had half a century to learn our trade. Fifty years in which to take Reserves off the out-of-bounds shelf. There is now more information about visiting Reserves than ever before. Access is open. There are footpaths and public hides from which pine martens and shy capercaillie can be watched. NNRs and now our National Parks are part of the local economy.

Out of all this new-found freedom there comes a price: personal responsibility. However we may enjoy the Cairngorms National Park, nature must come first. If we learn to accept that, the future for this special place and its wildlife looks secure.

Ross Watson has lived in the Cairngorms most of his life on an estate where his father is a hill farmer. He now works as Assistant Warden at the RSPB's Abernethy Forest reserve. He is also a member of the Scottish Youth Parliament, where he is chair of the Transport, Environment and Rural Affairs committee.

The Cairngorms has had a huge influence on my life and I hope to see it prosper to inspire future generations.

The designation of this area as a National Park is a great opportunity, but should not be thought of as the 'final frontier' for the Cairngorms, or indeed for Scotland. Ideas and projects that can benefit both wildlife and people can be pioneered here with the financial backing of the Scottish Executive. There is no reason however, why some of these initiatives should not be rolled out across the whole of Scotland. Instead of thinking in terms of park boundaries, why not look beyond the Cairngorms to the Highlands as a whole?

Looking after wildlife in the Cairngorms comes at a cost—not always financial. The government must continue to subsidise wildlife-friendly farming; Scottish Natural Heritage need to be given support to fulfil their duties; then there are personal costs—the visiting dog walkes who must keep their pet on a lead. To combat some of the financial costs involved there is the growing market in eco-tourism. As well as visitors bringing huge financial benefit to this area through accommodation, outdoor activities and visiting attractions, they are also being educated about such a fragile environment.

There are many who take the short-term view when discussing wildlife management in the Cairngorms. It is unthinkable to look beyond their own lifetimes. Before man started to segregate the area into farms, plantations and grouse moors, there were great expanses of natural wetland fen which is now either lived on or farmed. The Caledonian Pine Forest extended over expanses of ground that has long since been exploited by human activity. This forest was of huge importance to the biodiversity of the area and the loss of this, along with the species within it, has come at a huge cost and has had knock-on effects which man is still trying to manage.

The extinction of boar, beaver and wild auroch has impacted on vegetation, as there are now no large herbivores to break up the ground and open up areas for forest regeneration. The loss of the lynx and wolf has allowed deer numbers to reach an all-time high, causing problems for landowners and politicians. This has happened over many centuries, and we have to try and reverse the situation to halt the persistent loss of habitats and species. We can use the National Park and the people within it to do this—by changing the way they view the landscape. This land should not be looked upon solely as something to make money from, but as an integral part of their lives in which they share a responsibility for its safe keeping.

Adam Smith lives in Kingussie and works for the Game Conservancy Trust in Dalwhinnie. He is a senior researcher looking into the ecology of upland moors and their associated wildlife.

This view of the future is radical in the sense that it is a plea for making only slight and careful adjustments to the status quo in the Cairngorms. This is for two reasons. First, there are international conservation obligations to protect and enhance our heather moorland. That means that we should value our open managed landscapes as something worthy of protection and enhancement. These habitats and their associated animal communities are practically unique to upland Britain, while extensive forest and scrub moorlands are commonplace throughout the northern hemisphere. Secondly, our current pattern of upland management, much of it driven by production of red grouse, provides substantial, largely unsubsidised revenue for remote rural communities and its further decline could have a great impact on these areas. This is not lost on Fennoscandian land managers, ecologists and social scientists who are currently looking to improve the wise use element of their upland management.

With these views in mind, I believe that producing a sustainable harvest of grouse is the best way of ensuring the long term conservation of heather moorlands, particularly upland heaths. Moors that lose their shooting interest are also those that lose the greatest amount of heather cover. We need to support 'best practice' in grouse management; the legal control of predators, reducing grouse disease, managing grazing pressure and again improving the quality of muirburn.

Within this framework, setting quotas for protected predators with the aim of securing both grouse and predator populations should be considered, but only for those estates which (1) can demonstrate best practice and (2) can show predation caused by protected species is threatening the viability of the grouse as a harvestable resource. Though this may be perceived as a conservation conflict, it need not be: in its simplest sense a resolution to this conflict between grouse and protected predators could be achieved if the national/regional/local population of a predator species were in a sufficiently favourable condition to allow their populations to be managed. This will not be straightforward, but just because maintaining the status quo is easy and suits the preferences of one section of society doesn't mean that it's right. This applies as much to those who love their driven grouse as it does to those who wish to see more predators—leaps of faith are needed all round.

With these aims, there is little place in my view for additions to our wildlife through re-introductions; so much remains to be do to secure what we have already. There is no doubt that we need to maintain and restore our magnificent open heather habitats and it is fallacious to argue that this is a loss to conservation. Indeed, without support for these landscapes there could be a loss of conservation value and community in the Cairngorms and that, I would deeply regret.

ACKNOWLEDGEMENTS

A book like this is never solely the work of the authors, so we would like to thank the following (in no particular order):

For field and project assistance: Lassi Rautiainen, Slavomir Findo, Tommy Bryce, Mark Hicken, Ros Newton, Alvie Estate, Rothiemurchus Estate, Jim Gillies, Neil McInnes, David Jardine, Jon Hodges, Bill Rowlands, Jeremy Usher-Smith, Sally Dowden, Tom Prescott, Roy Dennis, George Ramsay, Jane Williamson, Alan & Sharon Cairns, Kenny Doyle, Bill Knox, Niall Benvie, Laurie Campbell, Neil McIntyre, Iain Fleming, Ross Watson, Dave Carstairs, Torgeir Nygard, Andrew Knowles-Brown, Wendy Price, Paul Hobson, Stephen Corcoran, Adam Smith, Trees for Life and the Cairngorm Reindeer Centre

For design skills: Catherine Read, Mercat Press

For financial support: Scottish Natural Heritage

For old-fashioned friendship: John MacPherson, Ole Martin Dahle, Ian Rowlands

For unending patience: Gale, Amanda and Sam

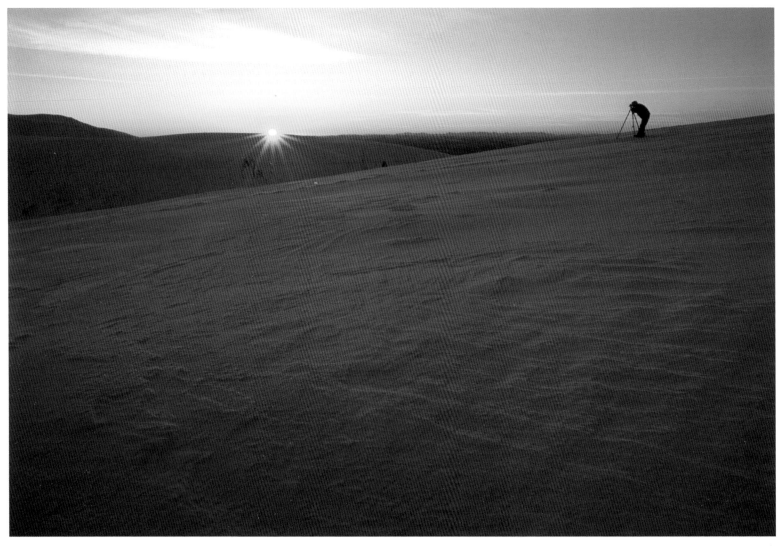

PC

First published in 2005 by Mercat Press Ltd

10 Coates Crescent, Edinburgh EH3 7AL www.mercatpress.com

ISBN: 1841830798

Designed by Catherine Read

Printed through Worldprint, Hong Kong